TALES *of the*
GLOBE TROT

MARILYN GLADU

FriesenPress

Suite 300 - 990 Fort St
Victoria, BC, V8V 3K2
Canada

www.friesenpress.com

ISBN
978-1-5255-9091-7 (Hardcover)
978-1-5255-9090-0 (Paperback)
978-1-5255-9092-4 (eBook)

1. Travel, Essays & Travelogues

Distributed to the trade by The Ingram Book Company

CONTENTS

PREFACE

HOW DID IT ALL BEGIN? Where did this wanderlust take root? Where were the seeds of adventure sown? What led a blond, female engineer to travel the world alone?

As a child, I had studied geography. My mother was a teacher, and so, naturally, I had one of those green and blue globes with the map of the world on it. I used to spin it around and around, never imagining that one day my travels would actually take me around and around that sphere.

I was the middle child from a middle-class family, but there was nothing average about me. I was a natural leader from the start. On the playground, I decided on and led the games the neighbourhood kids would play. At school, I was the ringleader. In my teens, I was the leader of the youth group at the local Baptist church. I started school early due to having a birthday in December, then skipped grade five, which made me essentially two years younger than my peers throughout my education.

Singing was a passion from the time I croaked out "Little Jesus Sweetly Sleep" in the Christmas pageant at age five, to

the bands I eventually sang in. Scholastically, I was an over-achiever, holding high grade-point averages, and excelling across the subject range.

The question of **What do you want to be when you grow up?** was for me a matter of practicality. Although I could have chosen many things, I wanted to have a career where I could always get a job and be well paid. My guidance councillor suggested computer science or engineering and then reneged and said I couldn't be an engineer, because it was a man's job and I didn't have the pre-requisite graphic-design credit.

There is nothing more likely to motivate me than being told that I can't do something. And that is how I ended up graduating as a chemical engineer, in a time when thirteen percent of graduates were women and the percentage in the workforce was less than five percent. In fact, I built a woman's washroom everywhere I worked for the first five years, because there wasn't one. Over what was to become a thirty-two-year career as an engineer, I worked for multiple multinational companies. It was thus that I became a world traveller and had the chance to explore and have adventures.

Through my twenties, marriage, two kids, and a divorce, my travels were an escape—somewhere to savour what was new and exciting, to breathe in a different life. In 2015, I was elected as a federal member of Parliament, and travel took on a new lens. I was working to improve our country and to learn from others. As one of fewer than 400 women ever to be an MP in Canada, and as the first female engineer in the House of Commons, I was proud to represent our country.

In 2020, when I ran for the leadership of the Conservative Party, I got to see regions of our nation that I had not experienced. Yet always there was the deliciousness of visiting a place for the first time—driving through it, meeting the residents. Experiencing the locations.

These tales then, are not a complete chronology of where I have been. They are just some of the places that left their mark on me, as perhaps I did on them. Come on the journey with me, as I take my first plane ride at the age of twenty-one, and begin the Tales of the Globe Trot.

Bermuda, 1984

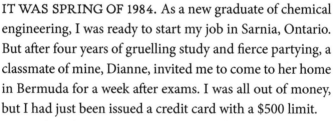

IT WAS SPRING OF 1984. As a new graduate of chemical engineering, I was ready to start my job in Sarnia, Ontario. But after four years of gruelling study and fierce partying, a classmate of mine, Dianne, invited me to come to her home in Bermuda for a week after exams. I was all out of money, but I had just been issued a credit card with a $500 limit.

So I bought an airline ticket, and we flew out of Toronto. I had never been on a plane before, so the thrill of looking out the window at the other side of the clouds in the sunshine was exhilarating. When we started our descent into Bermuda, the beauty of the turquoise water and white, sandy beaches, as well as the colourful landscape dotted with pastel-coloured houses was picturesque. It was so different from anything I had experienced in Canada.

Dianne's mother picked us up at the airport and drove us (on the "wrong" side of the road) to their house. Dianne had said her dad worked at the bank and her mom was a nurse. When we pulled up at their house, it was way fancier than I had expected. There were two motorcycles in the driveway. Her mom said, "Dad thought you might like to have those to get around on, so he got them from one of the companies he owns."

It was at this point, somewhere between the, "they live in a mansion" – and "he owns multiple companies," that I realized I was outclassed. Turns out her dad was the director of the Bank of Bermuda. However, they welcomed me warmly into their home, and other than their vicious Lhasa apso, it was great. After a lovely dinner, we swam in the family's in-ground pool, and had a few drinks before retiring.

The next morning, Dianne's dad was long gone to work by the time we got up. There were cinnamon raisin bagels for breakfast. Then, we went off to explore the island, which is twenty-one miles long and one mile wide. In St. George, we visited the oldest Anglican church outside the British Isles, where I was able to obtain a lucky nut (I know), and then on to spend some time tanning on Clearwater Beach. Dianne explained that the locals consider it too cold to sunbathe and go in the water in February, but coming from a place where we go in the water from the time it is 65°F, this was heaven.

We had signed up for an afternoon cruise. They served up rum swizzles (a delightful concoction of pineapple and orange juice with the famous Goslings dark rum) and toured us around the coast of Bermuda, giving a lot of

information about the history of the island. At one point, I was chatting to a couple we had met and I mentioned I was going to be starting a job in Sarnia. The woman exclaimed, "Oh, well, the water in Sarnia is exactly the same shade as in Bermuda." At the time, I thought she'd had too much rum swizzle, but once I started work, I found she was right on the money.

We returned home in time for another great dinner, and then decided we would check out the night life. So we took our motorcycles and drove into town. I was getting used to driving on the other side of the road. At The Pickled Onion, there was a great band with two cute lead singers, one blond, one brunette, with long shaggy hair, but doing the Thompson Twins routine perfectly. They were flirty with us all night and had drinks with us at half time, but we soon left them to return home. Tomorrow was to be a big day.

Dianne had arranged for us to meet up with a friend of hers and Christopher Atkins, from The Blue Lagoon fame. We entered the yacht club through the only entrance that women were allowed to go in (I know), and proceeded to the patio, where we met up with the guys for lunch and drinks. Chris, as he liked to be called, had the most perfect nose I've ever seen on a man. There was sunshine, great food and some flirtation, but I was over six feet tall and really, he was 5'8". Come on.

We returned after lunch. Dianne's dad had taken off early and we were going out on the family boat—well, the speed boat, anyway. The smell of the ocean, the beautiful sunshine, the turquoise water, and the eye candy of the Bermuda coast was a true experience. At one point, we

came up alongside the Bluenose II, admiring the classic lines as she picked her way through the waves. After returning for a late dinner, sunburnt, but at peace with the world, I fell into an easy sleep early.

The next day dawned and it was a bit drizzly. We went off to explore the island, touring around several switchbacks on our motorcycles. The roads were slick, and at one point I skidded and nearly lay the bike down. We decided to stop for fortifications at the Swizzle Inn. It was drizzly outside, but lots of fun inside. I had grown increasingly fond of Gosling's Rum, and the many cool drinks they'd invented. Earlier in the week, Dianne's parents had mixed up the famous Dark and Stormy, a mix of ginger beer and Goslings. This day, we decided on a pitcher of rum swizzles and a few games of darts.

I never did figure out why alcohol and sharp-object projectiles were favored together, but in any case, we finished up our swizzles and mounted up our cycles. In later years I would reflect back on this, in the aftermath of the rise of the Mothers Against Drunk Drivers movement, but in 1984, everyone was doing it.

That night we were invited to a party with Dianne's parents. When we arrived at Robert Stigwood's place, I saw it was a mansion with a huge guest house, tennis courts, boat house, and pool. We entered it and were ushered out to the pool area where folks were enjoying cocktails and appetizers. I reached for one of the Cheetos balls stacked up on a plate. If you have ever played one of those games where you remove the one straw or piece that causes the whole thing to come tumbling down, well, I had just pulled

out the exact Cheetos ball that called for them all to fall. Many around me laughed, and so I turned it into a comedy moment, launching into all of the embarrassing things that can happen with hors d'oeuvres.

As I circulated around the pool, I recognized Barry Gibb and one of his brothers. It was then that I put together that Robert Stigwood was the producer of **Saturday Night Fever** and that the friggin' Bee Gees were here at the party. Talk about the lifestyles of the rich and famous. But keep in mind, the dress I was wearing was worth twenty dollars. Good thing I had personality. I did meet Barry and Robin. The former was cute and tall, but hairy, and his brother was kind of quiet.

We left the party and settled in for another great night's sleep. The next day we toured Gibbs Hill Lighthouse. Dianne is terrified of heights, but as a symbol of our friendship she climbed the stairs and gripped the outer railing at the top, her knuckles turning white and her face pale. I had some mercy and we climbed down early, making our way to Horseshoe Bay for another great day of sun, sand, and sea.

That night, another of our classmates, Paul Kilbanks was arriving, and we had a great dinner celebrating our graduation. We drank up all the ginger beer with our Dark and Stormys, and crashed for the night. The next morning dawned bright and sunny. A perfect day. The family had decided we would go for a nice sail on their sailboat–a beautiful, twenty-seven-footer, sleek and white.

By one p.m., we boarded in bathing suits or swimming trunks and spent the day touring the island. Paul and I weren't very knowledgeable about sailing, so we sat and

chatted, enjoying the breeze and trailing our fingers in the lovely water. We had dinner at the yacht club before returning home for drinks and more conversation before bed.

On Sunday, we were to attend church with Dianne and her family. We filed into a beautiful wooden church and were seated in our pew. Ahead of us, Cheryl Ladd and her husband were seated. It was odd singing hymns to God next to someone I had only seen in the context of Charlie's Angels. After church we were to go to the Southampton Princess for brunch. This lovely pink hotel had an amazing dining room, with a buffet that went on pretty much forever. We were seated at a great table overlooking the water and joined by a number of others, including Lorne Greene, of Bonanza fame. He was fairly aged at this point, but still with a great sense of humour and lots of stories to regale us with while we enjoyed a brunch I never could have afforded. Thanks to Dianne's dad, I didn't have to.

We had a quiet afternoon by the pool, followed by a barbeque. I was due to fly home the next day, but I felt like I had been given the best gift ever. What a jewel this island is. Someday I will return.

California,
1985

CALIFORNIA DREAMING. HOME OF THE Beach Boys. Movie Stars. These were the musings of a twenty-two-year-old me. In a joint venture between my company and a medical manufacturer out of Concord, CA, I had been working on developing artificial kidneys from hollow-fibre membrane separations. It was thrilling to be able to go there to see the clean operation and to discuss the progress. I was to be accompanied by Mark, a senior chemist from the company. That's where the trouble began.

Mark was not a bad sort, really. He was a skinny, pasty-skinned, short guy with the horn-rimmed glasses that took over his face. Smart, but no social skills. Anyway, I was to travel with him to San Francisco, and then we'd rent a car and drive to the facility in Concordia and spend a couple

days there. Neither of us had been to California before, and being an explorer by nature, I suggested that we travel on the Saturday and spend time touring around before our Monday meeting. The company had a policy—since you could always get a cheaper flight if you stayed over a weekend, they would typically spring for the two nights at the hotel. Cheaper for them, better for us.

And so, we flew out together. When we boarded our flight to San Francisco from Toronto (business class, yeah!), the flight attendants came by with mimosas. What a great start to the trip, I was thinking.

"No thanks, I don't drink," said Mark.

Really? I mean, not surprising from this total nerd, but I was hoping he wasn't going to judge me. "I'll take his," I smiled to the attendant. Definitely a great start.

We arrived at the San Francisco airport. My eyes were everywhere, staring, but trying to look like I was not staring at the Hare Krishnas; taking in the busy turmoil all around; and trying to figure out where our rental car place was. Eventually, I spotted it, and pointed it out to Mark. We were given a burnt-orange Lancer. Since Mark was the senior representative, he was to drive. I was just as happy to have him drive because San Francisco was a huge city and I had only had my own car for a year.

That lasted up until we were in eight-lane traffic, and he was driving in the lane second from the left at a speed significantly below the speed limit. Cars were passing us on both sides, with lots of honking, finger gestures, and expletives. I was greatly relieved when we exited the highway, but as Mark began to pick his way through the city traffic, I

observed that he was a very hesitant driver—worse than a little old lady, in fact. Finally, in exasperation I commanded, "Pull over right here."

He looked startled.

I got out of the car and came around to his side. "Get in the passenger seat," I ordered. "I'm driving."

In no time we were at our hotel and safely parked. After check in, we met in the lobby where bright sunshine was streaking in through the windows. We decided to walk down to Fisherman's Wharf, which we did in companionable silence. We toured around, buying Ghirardelli chocolates, and enjoying fish off the wharf. Mark wanted to tour Alcatraz, which looked a bit gloomy and doomy, but hey, we were in this together, so off we went.

The tour was interesting, but long, and when we returned, he just wanted to go back to the hotel and have an early night. Seriously? Not me. So, I found a show called **Dancing Between the Lines**, ordered up drinks, and enjoyed some excellent dancing talent.

The next morning, we had agreed we were going to drive up to the Sonoma and Napa Valleys and tour the wineries. Mark also wanted to see the big redwoods and the University of California at Berkeley, but it was too much for one day. We crossed the Golden Gate Bridge and enjoyed the tour. Mark was a photographer and needed to stop every mile or so to take a picture of what appeared to be to me, the same scenery as back home. We got to the first winery, took the tour, and went to the sampling room, where I made him take a sample to give to me. I was starting to see the advantage to having a teetotaller for a tour

partner. Today I was letting him drive, since we were out of the city.

But after one winery that was enough for him, and he was keen to make it to the university. We arrived late Sunday afternoon, where instead of sitting in the bright sunshine enjoying the view, he insisted he wanted to tour the book store. I told him I would be happy to wait out in the sun, and that he should take his time, which he did.

We checked into our hotel in Concord, and I was able to get a break from Mark. The next morning we were sitting at breakfast in the hotel restaurant atrium, which had more trees than the outdoors, when suddenly the dishes began to rattle. Our chairs shook. The dishes rattled louder and louder and some things on the table tipped over. Then, as suddenly as it started, it stopped. No one in the restaurant even looked up from their meal. They all just continued like an earthquake had not just happened. For myself, having never experienced an earthquake (I had been asleep when the one in Kingston, Ontario happened in the eighties), I was a bit shaken. But I guess if you are going to experience California, you have to take the good with the bad.

The next two days of Mark and his fussy, old-hen ways were brutal. I was counting the hours until I could be rid of him. Wednesday morning, he was flying back to Canada. I had told my boss I would take a few vacation days.

Wednesday was a beautiful day. I dropped Mark at the airport and felt a euphoric freedom come over me. There I was, driving down Highway 1, looking at the Pacific Ocean, tunes on the radio, sun beating down. Magic. When I got to Pescadero, there was a lighthouse with a youth hostel

nearby. They had room for me for six dollars for the night. I paid, signed their register, said I'd be out for the afternoon, and off I went. I drove first to the Big Basin Redwoods State Park, where I took plenty of pictures with my Instamatic. I would be sure to show them to Mark.

From there, I continued down the coast to Santa Cruz. There was a beach there next to what looked to be a carnival with a big Ferris wheel. The beach area was pretty deserted other than a few tourists strolling around. It was 68° Fahrenheit, so for anyone but a Canadian, it wasn't sunbathing weather. I lay my towel down and relaxed into the sun-warmed sand. The sound of seagulls interrupted the serenity, but I lay there in total thankfulness, reflecting on all that I had seen and done in those few days.

By the time I got back to the youth hostel, it was just past five p.m. The common room was filled with four others— young guys in their twenties. I dropped onto the available chair and introductions were made. Two of them were cyclists from Sunnyvale, CA. One was a backpacker from Australia. The fourth was a hitchhiker from Vancouver. We chatted for a bit and then I said, "What's everyone doing for dinner?" It turned out there was only one restaurant in Pescadero, and I was the only one with a car. So we piled the five of us into the Lancer. (We all were over six-feet tall, so this was an engineering feat.)

The restaurant was one of those wood-panelled, cheery places with the red and white checkered tablecloths. We ordered up a pile of food, beer, and rum and Cokes and got to know one another. We were in no hurry, so we must have been there a couple hours. The sun was setting as I pulled up

at the hostel. I had gotten sunburnt, so my colour was close to lobster-red. I said goodnight to the guys and went into the ladies' cabin, where two other unknown women were sleeping in the camp-like bunkbeds. I put some moisturizer on, donned a night shirt, and was fast asleep in no time.

You may wonder how I could sleep in a bed like that, with strangers in the other bunks. Well, having been a camp counsellor for a decade, I was used to the lumpiness of camp beds. Plus, I had nothing to steal (except that which I kept with me under my pillow) and I was twenty-two, which says it all. The young never think they are going to come to a bad end. Or we think it, but we don't do anything to prevent it. We are trusting.

The next morning dawned as another beautiful day. I had decided to drive down to Pebble Beach, Monterey, and Carmel that day, then back to stay at the hostel. You couldn't beat six dollars a night. Highway 1 was as smooth as velvet, and I couldn't have enjoyed the drive more if I had been in a Porsche. I drove around Monterey and Carmel, past the movie star homes, and wondered which one Clint Eastwood lived in. I always loved his movies.

By the time I drove back up to Pebble Beach I was pretty hungry, so I decided to eat at the Pebble Beach Golf course. For forty dollars I had a hamburger and fries and a rum and Coke. Keep in mind this was 1985. The rule of economics says that prices double every ten years at seven-percent interest. So that's like more than $300 in today's dollars. Pricey for a burger, but definitely worth it for the experience.

After lunch, I went down to the beach and found a wind-free spot between the dunes. It was only 65 degrees, so not

a great sunbathing day, except for us polar bears. When the sun faded, I returned to the Lancer, and made my way back to the hostel, stopping for French fries on the way back. I hit the sack at eight p.m., so I would be well rested for my flight the next day.

I left the hostel early and stopped at McDonalds en route to the airport, where I savoured my pancake and sausage breakfast and coffee. When I dropped off the burnt-orange Lancer, I was almost disappointed. I mean, it was an ugly vehicle, but it had been a beautiful trip.

CHAPTER 3

Paris,

1986

I'M NOT SURE WHY AIRLINES make you arrive two hours before an international flight. I always seem to end up waiting an hour and a half. The flight to Paris from Toronto was a night flight, due to arrive in Paris at six a.m. This was only my third time on a plane, and my first time travelling to Europe, so the excitement I felt was exhilarating.

I was seated on an aisle seat with two younger German boys to my left. Their parents were seated on the aisle seat across from me and the middle seat. With the experience I now have from thirty-eight years of global travel, I would have immediately invited the parents to shift over to be close to their kids, while I took the middle seat. Well actually, with the experience I now have I would be flying business class, and would never willingly take a middle seat.

That's like trying to fit an unrolled sleeping bag back into its original case.

At any rate, my dinner was served. That's when the first kid needed to get up to pee. So, juggling my tray and drink, I stood up to let the kid out and then had to repeat that performance when he returned. After dinner, the second kid had to get up to pee. And so it went every hour all night long while the parents slept peacefully. I was continually awakened to get up and let these orange juice-drinking urination machines out. Yes, at twenty-three, I was bitter.

So, having been awake twenty-four hours, I arrived at the Charles de Gaulle airport in Paris. My plan was to collect my huge suitcase (Thor, it had been named by the family because it was huge, but certainly when you are going to be on the road for a week, it was perfect). Then I was to take the Metro into the center of Paris where I had arranged to stay at Hotel Ste. Anne. Being from a small town that didn't have a subway system, and with high school French that hadn't been tried in five years, I was slightly at a disadvantage in finding the right train to take, buying a ticket, and heading in the right direction to board—but I was doing it. Everything was going swimmingly until I got to the part where you put your ticket in the entry gate and pass through. Nobody had told me how that worked.

So, I boarded the correct train and was staring out the window, soaking in the French countryside and then the wonders of Paris, when the conductor came by and asked me (in French) for my ticket. I told him that I had put it into the turnstile at the airport stop. He then explained that the ticket pops up and you have to take it with you to show.

At this point I wondered what I would do if I was put off the train, but he was kindly and just shrugged and threw up his hands and moved on to the next person.

I had identified the right stop, and was able to exit the Metro, lugging Thor behind me. It was surprisingly warm for eight in the morning, and I was sweating from the effort. What I did not realize was that when you exit from Metro stops in Paris, you come up to intersections of seven streets, none of which are labelled. Good luck figuring out which way to go.

Off I started along the street in one direction, catching odd stares for dragging a suitcase the size of a small car. I asked a lady for directions and her French was so fast I didn't really catch what she was saying. But she pointed in the opposite direction from which I had come, so I started back that way. After a block or two, I still didn't see anything that looked like a Hotel Ste. Anne. I asked another person who didn't know where it was. I really didn't know what to do at that point.

A taxi was passing and I waved it down. I asked if he could take me to the Hotel Ste. Anne. He replied that it was just a few steps away. I was so exasperated I said, "Please just take me there." And so he did take me the hundred feet around the corner, and I was happy to pay and tip him well…well, I think I did. I was still getting my head around the four Canadian dollars to a French franc thing.

Finally, I stepped into the foyer of the Hotel Ste. Anne. I successfully checked in (en français), and was given a key to a room on the third floor. Apparently the elevator was broken, and so I had to drag Thor up three flights of stairs.

I was even more sweaty by the time I got into my postage stamp-sized room that did not have a deadbolt on the door.

I decided to take a shower before trying to get some sleep. The shower was more of a misting experience than truly cleansing, but at least the water was cool. I lay down on the lumpy mattress and tried to shut my eyes to get some sleep, but with the bright sun leaking in through the paper-thin curtains, it didn't appear that I would be able to sleep.

So I got up and decided to explore Paris.

The fashion of the day was chinos and golf shirts in matching shades. I was pretty in ice-pink as I put my passport, credit cards, and travellers' cheques in my waist belt and bounded down the hotel stairs out into the bright sunshine. This was a time before GPS and cellphones, so I took out my paper map and planned my route. This was also before the advent of the hop-on, hop-off buses, so travel by foot was the only affordable option. As I was walking down the Champs-Elysees headed for the Arc de Triomphe, a man in his late-twenties fell into step beside me and began to walk beside me.

"Bonjour mademoiselle," he said with a wide smile. "Il fait beau aujourd'hui, n'est-ce pas?"

Having been warned about the risk of purse snatching in Europe, I shifted my purse to the opposite side. "Oui, il fait soleil," I agreed.

"Ou habitez vous?" he asked

"Je viens du Canada," I replied.

"Et ou est-ce que vous iriez?"

"A L'Arc de Triomphe," I replied.

"Bon, je vais la aussi."

At this moment, he seemed harmless enough. He was dressed in very preppy clothes. He told me he was a student in Paris, studying philosophy. He asked where I was staying in Paris and I told him the Hotel Ste. Anne. Dumb, dumb, dumb.

Being fairly fast walkers, we were soon at the Arc de Triomphe.

"Au revoir," I said, and began to walk around the Arc, admiring the beauty of its architecture.

But he didn't leave. He followed me around, asking how I liked the Arc, and telling me something of its history. It was interesting chat to be sure, but I was beginning to get uneasy and wanted to get rid of him.

So, I told him that it had been nice meeting him, but I was off to the Eiffel Tower. Because it was a three-kilometre walk, I figured this would put him off and I turned and began to walk away.

However, he cheerfully said, "I'll come with you," and caught up, falling into step with me again.

Now, I was worried. I tried to keep the banter light as we walked along, but I could only think about the fact that I had told him where I was staying, and that I could not figure out his motive.

When we arrived at the tower, he said, "I've already seen it. I'll wait for you."

But I said, "No don't wait for me, I may be up there quite a while." I was so relieved when I got onto the tower and away from him. I was determined to stay up there quite a while, so that he would not be there when I came down.

Over an hour later I emerged hot and sweaty after all the walking and climbing in 40°C weather.

You can imagine my surprise when again, he approached and said, "Would you like to get a drink?"

Being hot and thirsty I thought, even if he's a serial killer, I need a drink, and as long as we stay in public I should be OK. I motioned to an outside patio and we sat down. Now for those of you who have not been to Paris, maybe things have changed since, but every drink there was served warm. They served me a warm Coke. No ice. Seriously. However, I drank it down and nearly choked on it when my companion said, "Would you like to sleep with me?"

I spurted, "No," to which he responded, "Why not?"

Grasping at straws, I said, "Because I'm married," which was a bald-faced lie.

But of course, this was Paris and he said, "So what?"

I replied, "Look, I'm not interested."

To which he said, "Fine, I'll leave you," and got up and left.

I was so relieved I didn't even mind paying for his unfinished drink. For the next two nights in my hotel room, I would not be sleeping well, knowing that there was no deadbolt and that he knew where I was staying.

However, I was young, and the youth know how to shake off the gloom and take joy in the moment. After my escape from him, I returned to the Champs-Elysees, where I found a great perfume shop and spent an enjoyable hour with the clerks, trying out and buying lots of different fragrances.

When I left there, I realized I was hungry, having not eaten since the airplane breakfast. It was late for lunch

and early for dinner, but I stopped at a nice restaurant and they were open. I ordered a meal and a glass of good white wine, and it came served, you guessed it, warm. There are some things that cannot be tolerated. And so I motioned to my waiter. I wasn't sure of the word for ice, but he asked, "Ice cream?"

But I insisted, "Ice, please."

When the French feel insulted, they retaliate. He brought me a big bowl full of ice cubes. Undaunted, I scooped a bunch of them into my wine glass and thanked him with warmth. I too can retaliate. I ordered a second glass and piled the ice into that one too.

By the time I reached my hotel with a full belly, I had been awake for thirty-four hours. I misted myself in the shower and then lay down for to sleep. I had a good, long sleep, but was wide awake by four a.m. I tried to go back to sleep, but really, after ten hours of sleep, there was no chance. I got up, put on a royal-blue dress, did my hair with a matching blue bow, put on my matching blue flats (remember it was a fashion thing then!), and by five-thirty a.m. I was out walking the cobblestone streets of Paris, in the cooler morning air just before the sunrise. I'm sure my mother would have had horrors just thinking about a young, single girl wandering the streets of Paris in the dark. I made my way to Notre Dame Cathedral and was surprised to find it open.

I went inside. There was no one in the pews, but candles were lit throughout the cathedral, and the priests had gathered on the second level. I could feel reverence in the atmosphere. Peace filled me. It was a feeling that I will never

forget, and is an image I would call to mind during stressful days in the future to bring me again that peace.

The next place I was to visit was the Louvre, but it didn't open until nine a.m., so I stopped for coffee and French croissants. You always imagine these will be fantastic, but mine were dry and tasteless. The coffee was like mud, and overall, I would say that all my culinary experiences in Paris were underwhelming.

When I arrived at the Louvre, I was the first one in line (no surprise). Being an engineer, I had already mapped out the most efficient path to the things I most wanted to see— the Mona Lisa and the Venus de Milo.

When the doors opened, I went at top speed to the room where the Mona Lisa was. I was the only person in the room other than the security guard. I approached the painting, which was way smaller than I thought it would be. I studied it from several angles to see if the eyes really did move as you did. Having checked this off my list, I made a beeline for the Venus de Milo, and was the only one there to behold this graceful piece of art.

I'm not much of an art person in general, but I did spend hours at the Louvre, going from room to room mostly looking at the gorgeous ceilings, while trying not to bump into innocent art observers. I also toured le Musée de Rodin to see Le Penseur (the Thinker) statue. That was about enough art for me. After the Opera House, Sacre-Coeur, Place de la Bastille, and a few rides on the Metro, which inevitably got me lost as I emerged from the underground to intersections never labelled, I considered Paris done and was ready to move on.

CHAPTER 4

Belgium,

1986

WHEN THE PLANE TOUCHED DOWN in Brussels, I had a moment of panic. This was my first business trip outside the North American continent. In Canada, I wouldn't have been old enough to rent a car. Here in Belgium, I was, and I did.

It was a nondescript, silver-toned car—automatic transmission had been requested. I had never learned to drive a manual shift. I got into the car, adjusted mirrors, and buckled up the seatbelt. I turned the key and fired the engine up. I tried to put the car in drive using the stick shift on the console beside me, but it would not budge. I took the owner's manual out of the console, but it wasn't in English. I was feeling pretty dumb at this point and scared to ask the rental car people how to put the car in drive because—let's

face it—who would rent a car to a girl who didn't even know how to put it in drive?

In exasperation I pounded my fist down on the stick shift....And it moved into drive. Yes! The trick with this car was to press down on the stick shift and then move it into the D position. Feeling relieved, I exited the rental car parking garage, and made my way out of the airport. I had a map beside me, and I had studied the route carefully. I had a history of getting lost. You could be sure that when given a choice of turning left or right with a 50/50 chance of choosing correctly, I would one hundred percent of the time pick the wrong direction.

Even when I felt like one direction would be correct, but knowing that I never choose correctly, took the other choice, I would still be wrong. In this case, I would follow the E40 to Leuven, then take the E314 to Steevort. I was to stay at the Hotel Scholteshof there and head to the polyethylene plant in Tessenderlo in the morning.

I loved the highways in Belgium—smooth and well-flowing. I was a bit of a lead-footed driver, and was comfortable at 120 km. What did surprise me was that many cars were going much faster than this. They would come up behind you at a terrific speed, and if you did not move out of the way instantly, they would flash their lights and crowd your bumper. One of those lessons was enough to inspire me to keep my eyes peeled in the rear-view mirror to be sure to get out the way.

I was feeling pretty pleased with myself when I successfully made it to the E314, but as I approached Steevort, I took an exit that then turned into a roundabout. A

roundabout? We didn't have those in North America then. I had no idea what you were supposed to do, and as a result ended up taking one of those turnoffs. In no time, I was in the middle of a country road with nothing but cow pasture everywhere. Naturally, the streets were not marked, so I literally had no idea where I was. I would have to stop and ask.

I pulled over at the first farm house I came to. A middle-aged housewife wearing a cornflower-blue dress with an apron came to the door.

"Sorry to bother you, but I'm a bit lost and looking for help with directions," I began.

The woman looked confused and what came forth from her mouth was a language that sounded a bit like Dutch, but certainly was incomprehensible Flemish. Belgium has regions that are French, and regions that have this mix of Dutch and French called "Flemish." She asked me something else, which of course I did not understand at all.

I held out my map and said, "Stevoort? Scholteshof?"

"Ah," she nodded and smiled. She pointed down the road in the direction I was heading then indicated a right turn. I nodded and thanked her. Back in the car and down the road I went. At the first opportunity to turn right I did, and in no time, I pulled up outside the Hotel Scholteshof.

It was like an old country mansion with a red tiled roof. I parked the car, and as I was getting my suitcase out of the trunk a tall, fair young man approached. "Hi! Welcome to the Scholteshof," he said, in perfect English. "My name is Christian."

"Marilyn," I said with a smile. I was so relieved to hear English, and of course, he was dreamy-looking. He took my suitcase, led me to the reception area, checked me in, and got my room key. Then he led me through the hotel to my room, pointing out a lovely bar area overlooking the garden where he suggested I could have a drink before dinner. I agreed and said I would just freshen up after my travel. I jumped into the shower, rinsed, and towelled off. I put on a royal blue dress with matching shoes and bow, and made my way down to the bar.

Christian came in and asked what I would like to drink. I asked for a pinot grigio. He returned with two glasses, and joined me at a table next to the window, looking out on a classic Belgian garden. He told me of the history of the hotel, including hosting visits from the queen. I shared my stories from the Paris leg of my journey, and the plans for the business trip. I was meeting researchers in the slurry polyethylene process, as well as looking at the Tessenderlo plastics extrusion process operation. I would be two days at the facility, and staying here at the hotel three nights.

After our drink, Christian led me to the dining room, where I was seated at a table covered with white linen and nicely laid out with dishes. I chose the salmon, which was preceded by greens from the garden and accompanied by fresh vegetables from the same. The sun was starting to set over the garden, sending the last rays across the lawn. After dinner, Christian joined me for a nightcap. We flirted together harmlessly over the drink. I was happy to say good-night and retire to my room after the long day. I wanted to

be fresh for the morning and make a good impression on my European colleagues.

Morning dawned on another bright and sunny day, and I drove to the Tessenderlo site without incident. The team was warm and welcoming. There was a tall, lanky, blond researcher named Annamie Mattheuws, as well as the head of the extrusion operation, Josh Von Stralen. There were several others too, including Joop Peters, a really smart, tall, dark, and handsome engineer. The day was spent reviewing the research, and then the team took me out for drinks and dinner.

At the restaurant, I was seated next to Josh. He was an older gentleman, who actually looked a bit like you would expect Santa Claus to look. He had a great sense of humour, and we hit it off well. It was he who suggested that he take me to a restaurant in Brussels the next night. He said it was a very good restaurant, and if I would pay, he would drive. I agreed. When I left the team, I was amazed that I could find my way back to my hotel in the dark.

When I arrived, Christian welcomed me and joined me for a drink in the bar. I shared the summary of the day and my plans to go to Brussels the next night. The next day passed quickly, touring the extrusion operation and discussing solutions to common issues between the facility in Sarnia and the one there. After work, Josh followed me back to the hotel, where I dropped off my car and joined him. The ride into Brussels passed quickly as we conversed. There seemed to be no traffic issues in Belgium.

The restaurant was an old building, all stonework and wood. When the maître d' led us to our table, I saw at

once why Josh wanted to eat there. The floor of the restaurant was transparent, and the restaurant was built over a waterfall. You could see the water flowing over the black rock under our feet. The menu was entirely in French, and while my French was pretty good, there were some words I didn't recognize.

For a starter, I chose a soup that had an impressive list of vegetables as ingredients and something called **homard**. Turned out it wasn't vegetable soup at all, but lobster bisque—which is incredibly unfortunate, since I am allergic to lobster. At least I learned a new French word. The rest of the meal was delicious, accompanied by wine, and finished up with Spanish coffees. When I got the bill, I just about had a heart attack. It was 300 Euros, which in 1986 was about 700 dollars Canadian. Yikes. Clearly, the moral of the story is to be suspicious when offering to pay for unknown delights. (When I tried to submit this on my expense claim, my boss said , " Well, that was nice dinner" , to which I simply replied " Yes it was ."Josh drove me back to my hotel. We had sort of run out of things to chat about, but he put on some classical music and we travelled in companionable silence.

I didn't see Christian until the following morning at breakfast. We chatted briefly about the dinner of the night before, and when I was ready to check out, he carried my suitcase to the car and hugged me before saying good-bye. Did I mention he was dreamy-looking? I wished I could have spent more time in Belgium.

Louisiana,

1987

THERE IS NOTHING THAT CANADIANS like more than going south in the winter. So you can imagine that when I got the opportunity for business travel to Baton Rouge, Louisiana in February, I decided to go early and have the weekend in the sunshine as opposed to the freezing drizzle at home.

I checked into the Crown Plaza Hotel around noon, donned my bikini, and took my book down to the pool. It was only about 68 degrees, but in the sheltered area in the sunshine, it was perfect for a Canadian girl. There was no one else at the pool, so I soaked up the rays and felt relaxation creep over me.

I had been there for about an hour when one of the hotel employees came out to start vacuuming the pool. He was a

burly black man with a nice smile and bright white teeth. He called out to me, "Lady are you crazy, sun-tanning in this cold weather? Where are you from?"

"Canada."

"Ha! It figures. This would be warm by comparison. What's your name?"

"Marilyn…what's yours?"

"Isaac Washington."

I thought he was kidding. Isaac Washington is the name of the bartender from the Love Boat TV series. But he was serious! We struck up a conversation. He asked me about the reason for my visit and told me some of the places I might want to go while I was in town. I asked if he had children, and he laughed and said he wasn't married. He then told me Baton Rouge was known for their "mud bugs" (he dragged out the pronunciation, like "muuuuuuud bugs"). Louisiana crawfish. Apparently a specialty. One of the guys from work had recommended a restaurant in Baton Rouge to me. It was called Ralph & Kacoo's.

Isaac said, "Yeah, I know Ralph & Kacoo's. That's a fine place."

So I mentioned that I was thinking of going there that night. I said, "Do you want to go with me?"

He said, "For real? You serious?"

I said, "Sure, why not?"

He laughed and agreed. "Sure, why not?" He said he would pick me up at six p.m. in front of the hotel.

I was standing out front of the hotel, dress rippling in the breeze when he showed up in a shiny, burgundy-colored truck with sparkling chrome. He jumped out

to come around to open the door and there he was in a burgundy dress shirt and matching burgundy pants with a heavy weight of gold chains around his neck. Quite a sight to behold!

As background to the story, keep in mind that this was 1987, and racist attitudes were prevalent, especially in the southern USA, home to the slave trade.

I got in and we began to drive up the highway. Although the banter was light and friendly, I did have an uneasy thought that it might not be a good idea to get in a vehicle with a guy I'd just met, when no one at the hotel knew where I was headed. Oh well, the folly of youth!

Ralph and Kacoo's was a great restaurant. As we were led to our seats, everyone in the restaurant turned to stare at us. It was a bit unnerving, actually. We were seated and ordered a bottle of wine, but I noticed we were still getting a lot of intense looks from the others dining around us.

Isaac said, "This is great. I am just trippin' here."

I said, "Yes, this is a really nice place. Why are all these people staring at us?"

He responded, "Marilyn, white girls don't date black boys here in the Deep South, and if you'll look you'll see that I'm the only black person here who isn't a waiter."

I scanned the room and saw that he was right. "Seriously?" I had never been confronted by the ugliness of racism before. Growing up, I can remember playing soccer at recess with Robby Takoshima and O'Neil Campbell. Robby's parents were from Japan, and O'Neil's family had moved from Alabama, but there was never any difference between us. We were all kids together, laughing, playing,

and part of the class. At university, it was a melting pot of people from all over the world, and again, each person was a source of new and interesting stories of different places. But we were all equal.

However, here, you could see that there was a divide. I wanted Isaac to feel more comfortable, so I took his hand and I said, "Well, I've got the most handsome date in the room, and we are going to enjoy our dinner!" There were a few gasps when I took his hand. I have to say, I was sort of enjoying being the agitator in the crowd. We took our time with dinner, exchanging stories about our upbringing, and telling tales from our respective jobs. When we paid the cheque and got up to leave you could sense the relief in the room. Back in the truck, Isaac said, "Do you want to go for a drink?"

I said, "Sure thing," and off we went.

Ironically, the next place he took me had all black people, and I was the only white chick in the place. I could see where a person could get uncomfortable being different from the people surrounding you. This sensation would fade over the years as I travelled alone more and more in places like Asia and South America, where a 6'2" blond stood out like a beacon. But that night, I put on my brightest and friendliest smile and we joined some of his friends. We had a couple drinks, danced a bit, and then he said, "Well, I've got to be up early." I took the cue and we hopped back into the burgundy-mobile and returned to the hotel. He dropped me off out front and said, "Thanks. That was actually one of the most fun nights I've had in a long time."

"I had fun too," I said. "Thanks, Isaac."

I never saw Isaac again. He wasn't working Sunday, and I was off Monday and Tuesday visiting the plant in Plaquemine and touring a plantation. Wednesday I flew out. As I sat in my window seat and watched the plane take off, I was left with the lesson that the world is full of friends you just haven't met yet.

Columbia,
1988

SPINSTERHOOD SEEMED INEVITABLE. AT TWENTY-SIX, I was trapped in a town full of 5'8" men with curly brown hair and baseball caps. It was a desperate situation. So I did what anyone would have done—I booked a trip to Columbia. I was going to signal to the universe that even if I was doomed to be single forever, I was going to make it interesting, damn it!

The place I selected was a resort in a little place called Santa Marta, along the coast. I got my Fodor's book of Spanish, and bought a thong bathing suit. Unfortunately, the week before my trip, I was playing tennis with Marvin Rosezweig (I know, the name alone should show my desperation), and I fell on my ass. Ended up with a huge bruise

the size of a grapefruit that was green, purple, and black. Definitely not thong material.

Just as well. As I was boarding my flight in Detroit to Baranquilla, I passed a missionary couple from my city. I said "How nice to see you—where are you off to?"

"A little place called Santa Marta," they said.

What are the odds? It is definitely a small world—too small sometimes.

When I stepped off the plane, the hot, humid air hit me. I went through customs, got my bags, and got to the bus that was going to take me to the resort. In front of the bus, there was a muscled man wearing camouflage, carrying an automatic weapon, and with rounds and rounds of ammo around his neck. I must have shown my alarm, because he said to me, "Well, we are at civil war." I must have missed that in the brochure. He continued, "We have some trouble here with violence—and if you resist, they kill you, so it's good to have protection."

Good to know.

So, I boarded the bus, and we travelled along perilous cliffs. I had seen this trip before in the movie **Romancing the Stone**. Didn't seem quite as romantic at this point. By the time we arrived at the resort, it was nine p.m. I was assigned my room, which was on the ground floor, and I was driven there on a golf cart by the staff. Once inside, I looked at the room. It was clean, with a pure-white bedspread on the double bed. There were French doors to the outside which were bolted into the cement floor with steel locks. However, there was about a one-inch gap under the door.

I saw a movement out of the corner of my eye, and was alarmed to see a gecko dart in under the door and begin to scale the wall of my bedroom. Seriously? I got into my pajamas, but my eyes never left the gecko. I was not a fan of lizards in general. I had a friend back home, Terry DeMarco, who had her pet boa constrictor named Casey, which she allowed to curl around her neck while we played cards. It always freaked me out. How was I supposed to close my eyes with the knowledge that a skittish lizard could be crawling over my face while I sleep? The answer is of course, you can't. And so, I didn't. When I got up the next morning, the gecko was gone, and I was exhausted.

However, with nothing to do but lie on the beach and drink, I decided to get a decent breakfast first. As I approached the dining room, a pristine, white-linen-everywhere sort of buffet, a tall (for a Columbian) 5'11" young man approached me. He introduced himself as Reuben, the entertainment director for the resort.

Reuben joined me for breakfast. I was keen to learn Spanish, so I learned how to ask for coffee and for my scrambled eggs (huevos revueltos).

Rueben told me there was an excursion that day to a coffee plantation. He was leading it. We would be stopping for lunch and then at a private lagoon for beach time. It sounded fun, and remember the whole point of this avoid-boring-spinsterhood trip was to do exciting stuff. It was a start. The coffee plantation was interesting. I bought fifteen bricks of coffee to take home.

The private lagoon was like a picture postcard. Beautiful sandy beach, clear water, people serving us drinks. At one

point, Rueben dropped down onto the blanket beside me and said, "Well, what do you think?"

I said it was beautiful, and then inquired, "Why, if this beach is so beautiful are we the only ones here?"

He said, "Well, the guy who owns it is an exporter, but he only needs it at night, so he lets us use it through the day."

Think about it. Columbia. An exporter who only uses it at night. If that doesn't spell drugs, I don't know what does. Oh well, it was a perfect beach day, and I decided to roll with it. I got a bit too much sun and was pleasantly sunburnt. By the time we got back to the hotel, it was dinner time. Rueben invited me to come to the show that night. He said there would be dancing.

I dressed up for the show. I was in a pink, flowing dress, with my hair in a clip with a matching pink bow. Rueben was in a white dress shirt and white pants. He was definitely sexy, and when he invited me to dance to "Do the Locomotion," I began to understand why girls love Latin men. The way they move their hips should be illegal. Anyway, I had a great time.

The next day, I had decided to go into town to check it out, since I needed a break from the sun. In my halting Spanish, I asked the taxi driver for the cost to go into town. We agreed on a price, and away we went. There wasn't much to see, but as I walked along, a tall, lanky, blond girl in a blue dress (with matching hair bow), young men began to follow me, excitedly calling to one another and cat-calling me. By the time a pack of ten had assembled, I was getting worried. As luck would have it, just when I was ready to find a taxi or a police station, I ran into the missionary

couple, shopping at one of the tourist traps. They invited me to join them for lunch, which I did, and then dropped me off at my hotel in their taxi before they went along to theirs. Divine intervention.

When I arrived back, I encountered Reuben in the lobby. He told me that it was Bingo time and that this would be a good chance to practise my Spanish numbers (he was good to coach me each day on new Spanish words). I joined the group, and it was a fun challenge to listen to the numbers in Spanish and try to get them right on my card. Afterward, I had dinner and then again ran into Rueben. He said, "Did you have a good time in town today?" I said I had, and then he said "And what did you buy?"

The reality was, I hadn't bought a thing. I had been hoping to get some emeralds, for which Columbia is quite famous. My mother's birthday was coming up and I thought maybe I would get some for her. So I mentioned this to Rueben and he said he had a friend who sold emeralds, and could get me a good deal.

So the next thing, I'm hopping into a cab with Rueben, and we take a short drive to some seedy kind of hotel. I'm immediately skeptical, but remember, anything is better than boredom in spinsterhood. When we entered the hotel room, there was another guy there. We sat down on the bed, and he took out a treasure trove of emeralds—the raw stones. I picked out one for a necklace and two for the earrings. It was a cash deal, $125. I was sure I would get home and find out they were paste imitations, but as it turns out they were assessed for $700. I ended up putting them into a gold chain and clip-on earrings for my mom, which she

loved, though she lost one of the earrings the first time she wore them. I never told her what I went through to get them. She wouldn't have approved.

It was straight back to the hotel, for more dancing. As we were pausing to have a drink, Rueben took my hand and said, "I want to marry you and come back to Canada with you." Finally, a chance to escape spinsterhood! But seriously, even though I was young, I wasn't stupid. I knew all about this marriage immigration-scam stuff. And although Rueben was fine for flirtation on holiday, I couldn't see him fitting into my lifestyle. I told him I was flattered and really liked him, but I wasn't looking to get married (a total lie).

He was pretty scarce for the rest of the trip, so I concentrated on reading on the beach and relaxing in the sun. I ended up getting sun poisoning, which caused blood blisters up and down my legs and on my shoulders. Not incredibly attractive. The rest of the resort got the flu after that, and the trip ended on a sour note. But I did get a laugh when I was in the customs area at the airport for the flight out. There was no inspection at all of our luggage, and so I said to the customs officer, "Are you not concerned about people smuggling out drugs in their luggage?"

He laughed and said, "Lady, we aren't worried about the bits in luggage. We're worried about the plane loads flying out every day!"

Good perspective.

Daytona Beach Shores, 1990

MY HUSBAND HATED MY PARENTS. We were newlyweds, and after a couple of visits where my folks had committed heinous acts like not taking their shoes off in the house and turning the TV up too loud, there was tension. In the hopes they would not visit often, Glenn made them feel unwelcome at every opportunity.

It was Christmas, and my parents were invited (by me) for Christmas Eve dinner. Then they were to stay Christmas Day and return home the next morning. Glenn and I were then headed to Florida with our friends Marion and Jim, an Irish couple I had befriended some five years earlier.

In an attempt to numb the pain of my parents' presence, Glenn had consumed most of a forty-ounce bottle of Canadian Club on Christmas Day. Presents had been

opened, the Gladu clan had descended and departed, bags were packed, and we retired for the night. Jim and Marion were picking us up promptly at seven in the morning for our long drive to Florida. Glenn was super hung over, riding shotgun as Marion and I chatted happily in the back.

We crossed the border without issue, and proceeded down our route, which would take us down the I-75 through Kentucky and the border states to our destination at Daytona Beach Shores. Along for the ride was Jim and Marion's seventeen-year-old daughter Kerry, a beautiful redhead with curves in all the right places and a wicked sense of humour.

The roads cleared out by the time we got past Ohio and into Kentucky. The rest of the world was celebrating Boxing Day in the stores, and the traffic was not bad. As we entered the Smoky Mountains, a fog had settled, making visibility difficult. With the roads winding and heading up hills and then steeply down into valleys there were many stop ramps for trucks where, if they couldn't stop in time, they could exit up one of these ramps that went nowhere but vertical to slow themselves down.

Interestingly, most of the truckers following us had no interest in this mechanism, but chose to ride the bumper of Jim's van. After a rest stop and lunch, Jim asked Glenn to take over the driving. The next hours were spent in deep fog, with truckers on our butt, and the fear of an I-75 pileup, which was common. As dinner time approached, Jim suggested stopping for the night, and we managed to find a Red Carpet Inn in Berea, Tennessee.

There was a liquor store next to the inn, with a limited selection. I bought us a bottle of peach schnapps and orange juice, in preparation for a "Fuzzy Navel" kind of night. We had burgers and fries at the nearby restaurant and retired for the night. We consumed the entire bottle of peach schnapps and the resulting evening events resulted in the conception of Glen's and my first daughter, Gillian.

The next morning, after an excellent Denny's breakfast, we hit the road. Jimmy was back at the wheel, and we were looking forward to arriving at our hotel on the ocean-front—the Aku Tiki.

We arrived just around lunch time, and checked in. Our rooms opened onto the beach, and were right next to each other. Everyone was hungry, so we drove to a tikki bar named DJs, on the beach. Grilled shrimp, French fries, beer and margaritas were the special of the day, and we were happy to have them.

After lunch, we went down to the pool to tan. Kerry had brought her New Kids on the Block dolls, and Jim and Glenn decided to do a photo shoot of these in various configurations.

Way too much beer. For dinner, we chose a local pizzeria within walking distance. The food was delicious, the company stellar, and we were ecstatic to be in a warm climate in the sunshine.

The next day, Jim took us for a tour of the sights—greyhound racing, the flea market, and, of course, we walked the beach. We were all a bit sunburned by the time we turned out for the early bird special at Aunt Catfish. Another meal

right up there in the top-10 list. We finished off the evening with drinks in the hot tub and a round of cards.

The next couple days passed in a blur of sun, sand, pool, and fine restaurants. At one of the restaurants, we had all gotten dressed up for the venue. The maître d' assumed Kerry and Glenn were together and Marion and Jim, of course. I was taken for the spinster aunt. They served Kerry drinks that night, to which we said nothing. After dinner, we played pool in some bar up the street.

The next day was New Year's Eve. Marion and I planned steak and lobster

(for them, not for me) with a salad and baked potato. It was a feast, with lots to drink, and cards to play and a toast on the beach at midnight.

I came back to this spot again two years later. As it turns out, both of my kids were conceived en route to the Florida vacations, so I took a miss after that until I was menopausal, other than one time when we took the kids to visit Disney and MGM. I was worried the whole trip I'd end up pregnant again. I have a great love for this place, where I encountered great friends and great memories.

Brazil,

1994

SMITH. WHO KNEW THAT EIGHTY-ONE million people have this last name? I never really thought about it...until I was trapped in a car in the Amazonian forest with a driver who spoke only Portuguese.

The day started like any other business trip. Up early, packed, and into the long, sleek, black limo. For most of my travel with the uber-frugal chemical company I worked for, I would have rented a car. However, you couldn't drop off a Canadian rental car to a U.S. destination, and I was going to be gone more than a week. Airport parking was highway robbery, and it turned out it was cheaper to get a limo to drop you off and pick you up—and safer. What an ego boost.

I flew United Airlines, Detroit to Chicago, to meet up with the cost accountant who was accompanying me to Guaruja, Brazil for a two-day audit. We had drinks before our flight, got into business class, and had more drinks and dinner before passing out for the rest of the fifteen-hour flight. Plastic eggs with yogurt, as per the usual airplane breakfast, and then we stood forever to get baggage and go through customs. My stomach was growling by the time noon hour approached and we finally exited to the arrivals lounge.

Laurie, the cost accountant, was telling me that she had arranged for the Dow driver to pick us up at the airport. She had landed in Sao Paolo last year for another audit, and it was a comfort to know she knew the ropes. As we entered the arrivals lounge, the hot, humid air hit us. Meeting us there was a large, burly fellow with a black, hairy beard (in fact, there was so much black hair on his arms and popping out of his shirt I thought he must be part bear). He was holding up a sign that said quite simply, SMITH.

Convenient, because that was Laurie's last name. But Laurie didn't recognize him, and she gave me an uncertain eyebrow raise. However, Mr. Bear picked up our luggage and began walking away...so we followed. He ushered us into a car and put the bags in the back. Then he got in and began to drive.

As we drove along, at first the scenery was a mix of the incredibly rich properties of Sao Paolo, with their wrought-iron railing gates protecting their wealth from the desperate. We then passed the acres and acres of slums, where the hopelessness of generations hung like a musty stench in

the air. I said to the driver, "Have you been driving for the company for long?"

He replied in a long string of Portuguese that really didn't illuminate me as to whether than was a yes or a no.

I fumbled in my purse to find my freshly purchased copy of Fodor's Portuguese/English phrasebook. "Do you speak English?" I asked, in butchered Portuguese.

Mr. Bear shook his head.

Meanwhile, an hour had passed, and the scenery was now big hills with manufacturing facilities on top and pipelines down the sides. Soon after, we began descending, down, down into a forest of leaves that looked like the plastic plants of Wal-Mart. With not many cars on the road, it was starting to feel remote. Laurie began to get uneasy and whispered to me, "This is not the way I remember."

That's when I thought to myself, this is why you don't use the name Smith to book a ride. Because really, if you want to abduct someone, you can show up at an airport, hold up a sign that says "Smith," and your odds of finding one of those eighty-one million people are pretty darn good. So now what to do. Was this guy going to kidnap us and hold us for ransom? Worse?

As a woman who prefers to know the situation and act accordingly, I again asked in my best Fodor's Portuguese where we were going, to which Mr. Bear responded "No comprendez." The forest was now behind us, and I could see the ocean on the horizon.

What to do? As strangers who didn't speak the language, as two beautiful girls in their early thirties in a land of passionate Latinos…fight or flight? Mr. Bear pulled up in front

of a building with iron bars on the windows, reminiscent of a prison. He jumped out of the car, and in a loud voice called out, "What is happening?"

Bellhops came out from the building, and in heavily-accented English said, "Ladies, welcome."

In fact, Mr. Bear was the designated company driver and just hadn't been able to tell us. Two hours of terror and sweat, totally wasted.

CHAPTER 9

Mexico,

1995

THE THING ABOUT THE PLASTICS that are used in appliances like fridges and dishwashers is that people don't want black specks in them. To keep them from getting black specks, producers put in additives to protect the plastic from burning during the heat-forming process. If there isn't enough protection, you get black specks.

And that is where my little adventure in Mexico began. I was responsible for quality for plastics in North America at the time, and the producer of forty percent of the appliances in North America was having issues with black specks in our product. I got the call and booked the first flight out the next day. At three a.m., I got up, got dressed, and drove the two hours to the airport. The flight path was from Detroit to Houston, with a connection on to Mexico City. A sales

guy named Gonzalo Salomez from our Mexico office was to meet me and take me directly to the customer.

I had only been to Mexico once before, to Cozumel, a stop on our honeymoon cruise. We had spent part of the day touring Mayan ruins and witnessing a fertility rite (which worked on me), and we lay on the beach for a few hours. The stellar impression left by that brief introduction to the country was about to be shattered.

I arrived at noon into the Mexico City Airport. No one holding a sign with my name was in sight. In fact, eventually no one was in sight. I stood there for an entire hour, stomach rumbling. I had eaten at three-thirty that morning, but other than the pretzels on the plane, I hadn't had a thing. I hoped Gonzalo would take me for lunch.

By one p.m. I figured Gonzalo was a no-show. Now what? I didn't speak the language, didn't have a hotel reservation, and didn't know where the customer was located, exactly. This was before the time of cell phones when I just could have called Gonzalo. Just when I was about to give up, a tall, slender, well-dressed young man approached at said, "Marlene, I'm Gonzalo. Sorry to be late. Lots of traffic. We've got to hurry now to get to the customer."

So, instead of lunch, we hopped into his car, and began to drive. Now, for those of you who have never seen it, driving in Mexico City is not for the faint of heart. If you have three marked lanes of traffic, you actually get about five lanes worth, with cars playing chicken with each other as they weave around trying to get out of the logjam. Once out of the city, I thought it might be a half-hour drive to our destination.

The scenery was like a Clint Eastwood Western: cacti spotted through a dry parched land, with the odd burro here and there. Speaking of parched, I was as well.

Our trip was a three-hour drive in total. We pulled up in the customer's parking lot close to the end of their business day. Four angry men met us at reception and immediately took me to the manufacturing facility to observe the problem. The next four hours (yes, four hours) were spent looking at various machines and different sheets of plastic, counting black specks, looking at rejected parts, and trying to soothe agitated men who spoke no English and were losing a lot of money by the minute. And, of course, nothing to eat. I did get water and a bathroom break, but by eight-thirty p.m., I was ready for something.

Gonzalo indicated we were taking them out for dinner. Although a meal with four angry men didn't sound like my dream, they had me at "meal." On the way to the restaurant, they decided it would be nice to take me on a tour of the city. They showed me the aqueduct and took me by the convent. Didn't drop me off there, thankfully.

We parked the car and picked our way along a little cobblestone alley. The alley opened onto a cobblestone courtyard, with the restaurant patio overlooking a garden. Three guys dressed up like the Three Amigos were strumming guitars and singing. It was a beautiful warm night, and everyone began to relax and smile as we were seated.

Gonzalo, who was interpreting, told me they were ordering the local specialties for me to try. At this point, I was ready to eat anything.

Or so I thought.

When the waiter came out, he placed two black iron skillets on the table. "The local specialties," he announced, in heavily accented English.

"What are they?" I asked.

"Ant eggs and crickets," said Gonzalo.

I thought he was kidding. Then I looked into the first skillet. In it were pearlescent oval shapes the size of jelly beans. Since I was the foreigner, Gonzalo spooned some of the eggs onto a soft taco shell, added some red sauce and presented it to me, motioning me to try it. Not wanting to inflame the situation, I rolled up the taco and bit into it. The squishy eggs mushed around my mouth and I thought I was going to throw up. All I could think about was that in about two weeks, Mexican ants would be hatching in my bowels.

My ability to speak Spanish improved instantly. "Una margarita sans sel," I requested of the waiter. Kill these eggs with enough tequila to make sure they don't hatch, is what I was thinking. While I was waiting for my drink, Gonzalo took my plate and scooped up some things from the second skillet. Crickets. Seriously, crickets. Black crickets, like the kind I had from time to time in the garage. And all of these Mexican faces looking at me, waiting for me to try them. Honestly, the things you do to appease customers.

I put the first cricket in my mouth. Pieces began to fall off (legs?) and I quickly munched and swallowed. Thank God, the margarita arrived and I could wash the stray bits down. With that, the rest of them began to eat the rest of the contents of the skillet and then the waiter brought a big dish of paella, which was quite good.

I didn't finish the ant-egg tortilla or the other cricket. "I'm so full," I told Gonzalo when the waiter returned to pick up our plates. It wasn't true, but there was no way I was eating the rest.

Gonzalo dropped off the customers with an agreement to meet them at the refrigerator plant at eight the next morning. We stayed at a Holiday Inn, and I was so exhausted I fell into a deep sleep as soon as my head hit the pillow. The next morning, a new group of angry men awaited. After examining parts and collecting additional samples, it was back into the car for the three-hour return trip to Mexico City.

On the way, Gonzalo suggested stopping for lunch. I wasn't sure where in the dry parched land with the cacti and the odd burro there was a restaurant, but he pulled over at what looked to be an abandoned brick building. There was one guy working there, and no customers. Never a good sign for a restaurant. Anyway, there was no menu, and it turned out the only thing they were serving was goat stew. Have you ever had goat stew? Don't. It is as bad as you would expect. After the first bite, I was done.

Gonzalo commented, "You don't eat much, do you?"

Not here I don't, is what I was thinking, but I just smiled and said, "Watching my girlish figure."

We continued on our way into the insanity of traffic that is Mexico City. When I arrived in Houston later, my flight to Detroit was delayed. I pounced upon a table at Chili's and ordered up the buffalo chicken salad with a glass of Chardonnay. Best thing I ever ate in my life.

So to make a long story short, I solved the black-speck problem. At least for a while. Eventually, I became leader for both North America and Latin America for plastics quality. When it was time for the representatives of the plant to get together for our strategy-planning session, I was able to persuade management that it was cheaper for us to have our meeting in Ixtapa at an all-inclusive, and we could meet a client supplied by seven of our nine facilities.

This time, a bunch of us flew on Monday from Houston to Mexico City, and we were to get a connection to Queretaro, the location of the client facilities. When we checked in at the gate in Mexico City, we were put on a shuttle bus. As the bus drove around the airport, we ended up in an area dotted with old, junky-looking planes. *This is where they put the planes when they can't fly anymore*, is what I was thinking. So imagine my surprise when the bus stopped outside one of them and we were invited to board it.

You know it is going to be a scary flight when they serve drinks before takeoff. Yep, seriously. Two drinks before takeoff. Interesting fun fact about Queretaro. The landing strip is really short. Or the pilot just wanted to slap the plane down hard and jam on the brakes—not sure which.

We stayed at the same Holiday Inn I'd stayed at the first time. Gonzalo had arranged for a van to take us to see the client. It was a love-in. No black specks. The van dropped us back at the airport for our puddle-jumper to Ixtapa.

I had brought my husband along this time. It was our tenth wedding anniversary, and I would have been in trouble if I was (a) away working, (b) at an all-inclusive

without him, or (c) anyway. When we arrived at the resort and checked in, we were met in the lobby by one of my team, who had been unable to make the client visit.

John was a jolly guy. He was almost as wide as he was tall, but always had a smile on his face, and on this trip, always a drink in his hand. We had a few drinks before dinner, and quite a few after. We had set a schedule to do three days of meetings and then enjoy the weekend before flying home. It was great to do meetings in shorts. I French-braided my hair, which was better with the humidity. John arranged for us all to go on a catamaran cruise that night. "Twenty bucks apiece," he chuckled. "Helluva deal."

We took the hotel shuttle to the quay. There was a shady-looking bunch, loitering around, plus an old boat that was loading people and taking them out to the catamaran. They loaded it up, once, twice, and then we were on. They also brought a boat load after us. I thought, How many damn people are they going to put on this catamaran? It was wall-to-wall people. My team and I took our spots at the front of the boat. The tequila shots and rum punch were being handed out continuously by agile, bare-footed staff. We sailed off into an exquisite Ixtapa sunset. It was fantastic. Between the pontoons there was what looked like a trampoline. Turned out it wasn't.

My co-worker Mark, (not the teetotaller), having downed more tequila shots than he should have, decided to jump on it and fell down instead. As he lay on the material looking up at the sky, I could see the safety-graph report on this one: "Worker drowns while drinking tequila on a

quality network trip." Definitely career-limiting. We got him back up with the rest of us safely.

It was at that point that I realized the other Mark wasn't with us. I found him at the back of the boat, retching into the water. "I get seasick," he said, between hurls.

Was it the right time to tell him this was a three-hour cruise? Probably not. I stayed with him for a bit, until he said he would rather throw up alone. I returned to the team, who by this point were laughing and chatting and enjoying the warm breeze and the occasional ocean spray. Everyone hit the sack early, with an agreement to delay the start of our morning meeting until ten a.m. due to too much tequila.

We were in surprisingly good shape the next morning (even the two Marks). We finished our meeting early and enjoyed some pool and beach time. The next day was our last meeting day, but we had made so much progress we were able to finish up by noon. My husband and John decided to go golfing.

Normally, I would have expected them to be gone for about five hours, with travel time included. So you can imagine my surprise when they showed up at 3:30 p.m. Apparently, my husband had hit a shot off the tee that winged sharply to the right, and when they heard the sounds of shattering glass, they knew they had hit "El Capitaine's house," as John put it. Worried that they would get arrested and trapped in a Mexican prison (another career-limiting outcome), they had called the game and returned home. No one showed up to arrest them and the rest of the trip passed without incident.

I never did return to Mexico after that, with the thought of an outstanding warrant for my husband. Perhaps I will go myself again one day.

CHAPTER 10

Almeda Genoa Road, 1998

TEXAS IS A NATION SURROUNDED by America. At least, that's what they told me when I travelled to the company location in Lake Jackson. I had been there many times since I started with the company. I would fly from Detroit into Houston Hobby airport, rent a car, and drive to the La Quinta hotel. It was mid-winter, and I had flown in wearing my cowboy boots and fake fur coat, and sporting my sunglasses with the candy-pink plastic arms. Since I rented a lot of cars, I was always being upgraded. This time, I was upgraded to a gunmetal-grey Cadillac STS with spoked wheels. Styling.

I got into the rental and arranged all my stuff. When traffic was bad, I had found an alternate route down Telephone Road to Almeda Genoa Road to the 288. I had

taken this route many times. Making my way out of the airport circuit, I turned onto Almeda Genoa Road. This is quite a long road that stretches though many lonely and sort of run-down areas. I was in just that sort of area when my tire blew out and I was lucky to pull safely to the side of the road.

These were the days before cell phones. The closest building to me was a sort of run-down wood shack with a lot of junk strewn around the property. Oh well, any port in a storm. I trudged up the weedy drive to the door and knocked. There were a few odd noises inside before the door opened up and a fellow appeared.

Now, I have not met a lot of axe-murderers. But if you imagined what an axe murderer looked like, you would have envisaged this emaciated, smelly man, with a scruffy white beard and single-digit teeth. The only good news was that he was a lot shorter than me, and I figured that, without the axe, I could take him. He looked at me, standing there in my fur coat, candy pink shades, and cowboy boots. "Hi. I've got a flat tire, would it be possible for me to use your phone?" I asked, in the nicest, calmest voice possible. I wasn't sure if this guy would even have one.

"Sure, c'mon in," he said, and shuffled through a hoarder's fantasy to a table upon which was an old dial-up. It is at times like this that is a comfort to know that CAA (the Canadian Automobile Association) has a reciprocal relationship with AAA (the American counterpart). After a brief conversation, and confirming exactly what address on Almeda Genoa Road I was at, they told me they should be there in under an hour. Great.

"Thank you so very much," I said to my host, "I can wait in the car."

"I won't hear of it," he said. "Let's have a drink."

I am convinced that the poor soul never got to see anyone, and was thrilled to have a visitor present on the doorstep. He poured Jack Daniels (straight). On the one hand, I was thinking about the company policy regarding alcohol consumption and rental vehicles. On the other hand, I was thinking of a very lonely road, a questionable individual, and an hour before the AAA guy showed up. I took the drink.

Over the next hour, I heard the sad tale of how this gentleman had been injured in the war, had difficulty finding work, had turned to the bottle, and had lost his wife and kids in a car accident. Heartbreaking. I shared words of comfort, and told him about my life journey.

By the time the AAA guy showed up, we were fast friends. The tire was repaired in no time, and I thanked my host and got into the car. He waved to me from the porch as I was driving away. You never can judge a book by its cover.

CHAPTER 11

England,

2001

I HAD HAD MANY ADVENTURES in England. When I was twenty-two, I had flown on Sabena airlines from Belgium (my colleague called Sabena Such a Bloody Experience Never Again) and had my luggage lost. It was amazing that you could travel around London, England without makeup, wearing your pajamas, and no one even gave you a second look. I met a girl named Nala, from Israel, on a bus trip to the Roman Baths and Warwick Castle, and I had eaten more mutton lunches in one weekend than anyone should have to. I fully understood why people ate lamb in England. If you didn't, the bloody things would take over the entire country! I had toured Cardiff and gone to several castles, and I had been to the many company

sites. It was another experience entirely when my mother wanted to tour.

My father had died in 2000. He had not been one to travel. My mother, however, had been quite a pioneer in her younger days, crossing Canada by car with a girlfriend when they were in their twenties, just after World War II. It was a rare thing in those days for two twenty-somethings to be crossing the country on their own. So, when my mom said, "I would love to see England at seventy-five years of age," I wanted to make it happen.

I planned out a route with a tour—London to Cambridge, then onto Darlington, Hadrian's Wall, then onto Edinburgh for the World Art Festival, then down Gretna Green to Chester, to Wales, to Stratford-on-Avon, and then back to London.

My mother and I flew out on an Air Canada flight. To fly all night and arrive for transfers to taxi, etc., was quite taxing, and by the time we checked into our hotel at Kings Cross, she was exhausted. So much so that when entering the elevator, the door closed on her arm. Although it opened again, and we got safely to our rooms, the back and blue bruising went from wrist to elbow and took weeks to subside.

She had an afternoon nap and then was interested in having dinner. |I had heard that food was terrible in England unless it was ethnic, so I took us for some Thai food at The Box. The food was terrific, and I drank an entire bottle of white wine myself. My mother snored like a dragon, so I needed to be prepared. We returned

to our room. Thankfully, I was asleep before the dragon roar began.

The next day dawned a classic English day—rain. We had decided to go to Harrods to shop, then to take in Miss Saigon at the Covent Garden theatre. The shopping was a cornucopia of opportunity and we stopped for lunch at a pub across the street. My mom chose a scrambled-egg breakfast, and I chose a tuna fish sandwich. I mean, how can you screw up a tuna fish sandwich?

The sandwich arrived. It was on a ciabatta (and by that, I mean a piece of bread so hard and dry it would break your teeth). The tuna fish was literally bits of tuna that had been pierced by someone's harpoon; in chunks, with no mayonnaise. And for twenty Euros (nearly fifty bucks at the time)! God, I was beginning to hate English food. I hadn't experienced this before on my previous trips, because I always had breakfast at McDonalds, and dinner at Subway.

We left the pub and proceeded to the theatre for the play. It was awesome, and it felt surreal to be sitting in London watching it. We returned to the hotel, and ate at a pub on the corner. (Again my mom was smart to get fish and chips. I had a hamburger that was raw in the middle and dry.)

The next morning, after not sleeping well (not enough booze to counteract the dragon's snore), we boarded the Evan Evans Tour bus, our luggage intact. What a delight to traverse the countryside with narration (in a British accent) to disclose history and fun facts. We stopped at Cambridge to see the university and to tour the shops. My mom and I both bought wool sweaters with Celtic clips. Her credit card wasn't working, so mine sufficed.

Onward we went to overnight at Darlington. There we had a lovely dinner with the whole tour contingent. In preparation to counteract my mother's snoring, I again downed a bottle of wine, of which she was critical. However, we retired, and we both slept blissfully. The following morning, we went down for breakfast and dutifully boarded the bus. We toured along Hadrian's Wall, stopping to purchase Scottish wares, and finally arrived in Edinburgh.

It was during these stretches of bus tour through the countryside that my mother and I had long chats. She regaled me with tales of her travels across the country with her girlfriend when they were young. She reflected on her life as a wife and mother, and spoke of places she would still like to go. The apple doesn't fall far from the tree.

The hotel put on a classic Robbie Burns dinner, with neeps and taters, the toast, and Scottish highland dancing. My mother was thrilled, though rather watchful of the forty-something tour guide who had been shamelessly flirting with me from the get-go and was now liberally buying me drinks. I was taking these as a deposit towards dragon snoring, not really considering a fling with a near-balding tour guide.

The next day dawned bright and perfect for a tour of the castle. Mom and I walked extensively there and back. For seventy-five, she was pretty spry. She wanted an afternoon nap, and I contented myself at the hotel pool. We enjoyed a great dinner at a Scottish pub, and were well rested in time for the next day's trek.

Gretna Green is a place just on the border from Scotland to England. Historically, many a young couple, seeking

to be married, escaped to Scotland where they could be married at sixteen. When we arrived there with our tour, we were surprised and pleased that a couple with us had arranged for their marriage ceremony to be performed there. She, in her white dress and a flower circlet in her hair, and he in his morning suit, an Asian couple who allowed us the privilege of witnessing their nuptials. It was wonderful. Happiness and love filled the air.

We made our way from there to Wales briefly, where I had the pleasure of seeing not just sheep, but my own tee-totalling mother at a Welsh pub, pouring a draft beer into a glass. Precious! From there, we visited Chester, the walled city, and enjoyed walking about and shopping, and another good pub dinner before retiring.

The next day was Lake Country: home of the poets, and a run up a mountain. I thought about participating, but didn't want to leave my mom. The beauty and peacefulness of that country remains with me today, and I gained an understanding of why many great poets sprang forth from that place.

Lunch was Stratford-on-Avon, and a play. Wonderfully done and a magnificent tour. By the time my mom and I returned to London, we were exhausted, but our hearts were full with experiences. Although my mom had a bucket list of many more places in the world to see, and she did see several with other people, this would be the last trip of substance that we did together. I keep it as a shared treasure in my heart, and think of her anytime England is mentioned.

CHAPTER 12

Leipzig,

2003

I HAD FLOWN IN ON Luftansa from Brussels. I always loved that airline for their German precision and attention to detail, and the great service. Always on time. One of my team, who had just been promoted to leader for the European area, picked me up at the airport. Ulrich Reifert was intelligent, well-mannered, and hardworking. He had the respect of the team, and it was a pleasure to see him.

We went directly to the company facility for the audit. Everything was ship-shape and in order. No surprises there. Ulrich's wife and daughter joined us for dinner at the Drogerie restaurant. We hit it off very well. After that leisurely but excellent dinner, I was dropped off at a local castle that had been turned into a hotel. It was a historic

landmark, and Ulrich filled me in on the history of the place on the way.

I was excited to stay in such a regal place...until I entered the room I had been given. The room was starkly decorated with a wooden bed in the one corner. Being very tall, I was dismayed to find that only three-quarters of my length would fit on the bed regardless of the direction I tried. Even more of a problem was the thin cover on the bed that also would only cover three-quarters of me. Did I mention that this room was right under the clock tower and the clock bell rang every fifteen minutes? The sound of the bell was so loud and close that it rattled my fillings. It was not the sweet ringing of a carillon. It was a GONG GONG GONG that hurt your ears.

However, my German at this point was fairly sparse and when Ulrich had helped check me in, there hadn't seemed to be a lot of English happening. I wasn't sure how to ask about getting moved to different room in German. Ulrich had arranged for them to call a taxi for me for eight the next morning, so that I could fly out to my next destination.

If you are good at math, you will know that between nine p.m. and seven a.m., when I had intended to get up and shower, the clock tower would ring forty times. I know. I was awake for each of them. On future visits, I stayed elsewhere. Less culture, but more sleep.

But this trip did yield one thing—Ulrich's daughter Anna agreed to be the au pair to my girls that summer. Ulrich and his wife came for a visit and then came back again to pick her up. Bonds forged on the globe trot.

Thailand,

2004

I WAS PREPARING FOR YET another Asia-Pacific trip; this one a twenty-one-day jaunt. These were interesting times. I was starting in the Netherlands, where the concern was a mad-cow disease outbreak. I was then flying to Thailand, where they had bird flu, and was continuing on to Hong Kong, where they had just gotten over SARS. The world was becoming a more dangerous place to roam, and this was long before Covid 19 showed up.

The flight on KLM was overnight to Bangkok, and I had been given the joyous seat right next to the kitchen, where the flight attendants rattled dishes and chatted and laughed all night so that I couldn't sleep. We arrived in the morning, and I was met by the company driver. Like many Thai men, he was slim, well-dressed, soft spoken, and polite.

As we drove to the hotel, he said, "I can take you to see some sights here, if you like."

"No thanks," I replied. "I have only one thing I have to do, and that is buy some Thai silk for my dentist." My dentist was a tall and talented lady, and was wanting to make herself a dress from the material.

"I will take you," said the driver.

"Well, I have to change some money into Thai baht," I replied.

"I will take you," said the driver. "Better exchange rate than the hotel."

He pulled up at a location where a man moved two pylons out of the way so he could park directly in front of a store. I followed him into the store.

Inside was a table, two chairs, a pencil, and a calculator. And that's all. It seemed really sketchy to me, but there I was. I took out several hundred dollars in travellers' cheques and in no time, I had 1200 baht. I asked no questions about the operation, since everyone was quite polite and they seemed to know the driver well.

He then took me to another store and again, when he pulled up, men removed pylons so he could park. I entered this store called "James Fashion," and it was full of beautiful skeins of Thai silk of all colours and designs. I searched until I found one that matched my dentist's request, and went to take it to the cash register. Another very well-dressed man approached me and looked me up and down. Then he said, "We can make you a suit."

"Well," I began, "I'm just here overnight, and then I'm headed out to Rayong province on Sunday for an audit

Monday, then right back to the airport hotel to fly out Tuesday, so I don't really have time."

He looked at me and said, "We'll measure you now, the driver can bring you for a fitting tomorrow before you leave, and we will deliver the suit to the airport hotel." He showed me the price in baht on the calculator. I paused to think about it and was not too sure. He then put a lower price on the calculator. It was certainly reasonable, so I agreed. I found material that was a beautiful royal blue edged in gold for the suit—traditional Thai top, skirt in gold print, skirt in the royal blue. It was agreed.

He asked for my credit card and said, "While we process it, come and sit down and have a drink." They brought me a Coke. A few minutes later he came back and said, "There is something wrong with this credit card, do you have another?"

Now I was again suspicious, but I handed over a different card. Then he took the details of the hotel I was to stay in Monday night. I was contemplating how many times you could be scammed in Thailand in one day, when he came back with the card and pronounced that all was well.

A woman about four and a half feet tall came out to measure me, which was quite a job since I was a foot and a half taller than her. But she had a stool, and made quick work out of the measurements, busily scribbling them down in her notebook.

"See you tomorrow at eight a.m.," she said.

The driver and I got back in the car, and he drove along a route near the palace, so I could see some of the beauty there. I was staying at the Novatel hotel in Bangkok. As

we approached, he pointed to a restaurant about a block from the hotel and he said, "That's a good place to eat. Good Thai food." He presented me with his business card and said he would return to pick me up at seven-thirty the next morning.

Once I checked in, I was headed up to my room for some sleep when I saw from the elevator buttons that there was a pool on top of the hotel. It was February, I was from Canada where I had left sub-zero temperatures, and it was 40°C here. Sleep is overrated. I decided to get my bathing suit on, (I always packed one in case), and to head on up to the rooftop.

It was a dazzlingly sunny day and really hot. I slid into the cool water of the pool, surprised to find it refreshing, and not bath-like. I floated around, looking at the azure-blue sky and then got out and flopped down on one of the chaise lounges, eager to sunbathe. It wasn't long after that the heat of the sun had me thirsting for a drink. I thought I could really go for a rum and Coke. However, I wasn't sure if beverages were allowed at the pool, and there didn't seem to be any servers, so I just sighed and settled down to bake.

Out of my bliss, I heard an Australian male's voice saying, "Hey there, can I buy you a drink?"

With experience, I had learned to avoid letting strange men buy me drinks, but in my desperation for a drink I called out, "Sure, I'll have a rum and Coke, thanks."

Immediately a server appeared and took our orders, and then the gentlemen sat down on the chaise lounge next to me and introduced himself, "Hi I'm David Reynolds, general manager for Just For Men Haircare for the Asia

Pacific." I told him my name and company position as well, and we fell into easy chat. When the drinks arrived, the waiter presented me with the bill. David said nothing, so I just signed the bill to my room and figured, Hey, at least I got a drink.

The afternoon passed amicably with a few dips in the pool and a couple more drinks. Finally, I said to David, "And what are you doing for dinner tonight, David?" He said he hadn't made a plan, and asked why. I explained about the restaurant that the driver had recommended and we agreed to go. We went back to our respective rooms and changed, meeting in the lobby for the short walk to the restaurant.

The restaurant was decorated in typical Thai fashion, with lots of Hindu statues and decorations. No one spoke a word of English but we pointed to various things on the menu, (starting with a bottle of wine), and soon had several delicious, steaming plates of food to share. The meal was great, the conversation excellent, and soon it was nightfall. David inquired if I had ever been to the night market in Bangkok. I said I had not, and he suggested we go.

It may have been the influence of drinks and wine and no sleep, but I agreed, and in no time we were riding the subway and exiting onto stairs that led into the bowels of Bangkok. For anyone who has never been to Thailand, it is important to note that all the signs are in Thai script. If you don't read Thai script, you don't know where you are or where you are going. So here I was with a guy I didn't really know, in some place in Bangkok that I also didn't really know, and I was headed to the night market.

The market was a buzz of activity. It had lots of different stalls with their colourful products displayed—knock-offs of every variety, souvenirs, clothes, jewellery, you name it. David said, "Now when they show you their first offer on the calculator, cut it in half and keep negotiating until they cry or show you pictures of their children."

I laughed, but followed his instruction. Soon I had collected something to take home for everyone on my list.

David then said, "Let's have a drink and a culture tour." He led me to a bar, and ordered us drinks (this time he paid).

I looked around the bar. It was a host to drug addicts, prostitutes, and the general scum of the earth. "Nice place," I said to David. I knew I should be more worried, but my instincts were that David was a good sort. He had a daughter about my age, and I thought that boded well. At any rate, we finished up our drinks, headed back to the subway, and I don't know how, but we made it back to the hotel. As we entered in through the lobby area there was a band playing.

"Another bottle of wine?" David suggested. I agreed. We sat in the lounge, danced and drank the wine. A nice end to a great day. After that, we said our farewells and went our separate ways. I never saw him again, but it was such an incredible interlude.

The next morning, the driver arrived promptly and took me to the store. I was actually sort of surprised and relieved when the small woman that had measured me showed up with the partially sewn and pinned blue suit and skirts. I figured, hey, for sure they won't be able to find someone else to fit this. The fitting was completed, and the driver

then stopped at a second hotel to pick up John Moyer, the plant manager from the California facility, who had flown in to participate in the audit of the Map-Tha-Phut facility.

The drive took about three hours. John and I chatted while we looked out at the scenery. I was pleased to see that the traffic signs on the highway were in English.

We arrived at the place we would be staying. It was an apartment complex where you basically could rent the apartments through the day. John had other meetings planned that day, but we agreed to meet for dinner. I went down to the gym to work out and guess what I discovered? A beautiful, outdoor pool.

So, it was back to the room, and another great afternoon of sunbathing. No drink service, but I did bring water this time. Before meeting John in the lobby, I went to shower and change.

"We have two choices," he said. "There is a restaurant here in the hotel, or there is one in the village, and we can get a Thai massage there."

The massage sounded like an experience I needed to have, so we began the walk into the village, which was a couple kilometers away. As we were walking along the grass-lined dirt road, I heard the sound of an elephant trumpeting. I turned to my right and there was an elephant! A real live one—no fences, no anything—right there. I was so surprised I didn't know what to do, so we just continued to walk along. I asked if we should go through the grass to try to see the elephant close up and John said, no, there were snakes in the grass.

I have a real hatred of snakes. I shifted to John's other side so he could be the one walking closest to the grass.

We arrived at this "restaurant". At the front, sixteen girls were seated, each wearing a number. I turned to John and said, "It's a bordello."

He smiled and shook his head and said, "No, it's a restaurant with Thai massage on the side." So we ordered up two girls and they came with clean robes in their hands and motioned us down the hall and into one room. "Take off clothes," the one girl said, handing us the robes.

I looked at John and said, "Well John, this doesn't conform to the respect and diversity policy of the company."

He said, "Well, what am I supposed to do? I don't speak Thai."

So I said to one of the girls, "Two rooms?" and made the corresponding sign with my two fingers. The next thing I knew, they had stretched what was like a clothesline across the room and hung a sheet on it—John and one girl on one side, and me and the other girl on the other. I was having serious doubts. However, we put on the robes, and the girls began the massage. They were chatting back and forth to one another in Thai and laughing and giggling.

I could definitely see why. First of all, my legs were nearly longer that the body of the girl trying to twist me into a Thai pretzel. She could hardly get her arms in position. Secondly, John is a hairy beast. Hair front and back, which of course is not the way most Thai men are. So, the girls' amusement and chatter continued. I thought maybe the massage would take a half hour. It was two hours by the time they were done and all for twenty dollars. For both.

I was definitely ready for dinner and a drink. There was no hard liquor on the menu, so we ordered up the only thing on offer, which was a bottle of rosé. Many fourteen-year-old girls in long dresses with big slits up the side were trying to sing karaoke on the stage. John noticed there was only one other man in the place. I said, "Yes, well it's a bordello, and he's the pimp."

We ordered the meal and were in the middle of it when John turned to me and said, "I think you are right—this is a bordello." By the time we finished our meal, it was dark out. I mean pitch-black. No street lights. We found the dirt road and began to make our way back in the direction of the hotel. I was ever worried about snakes and whether we would get bitten. About halfway back, a truck came up the road and slowed down motioning us to get in. John said, "What do you think?"

To which I responded, "Are you friggin' crazy?"

We waved the driver on and continued until we arrived safely back at the hotel.

The hotel was located right on the Indian Ocean. The moon had come out, and it was large and bright and beautifully white against the dark sky with a blanket of stars. A warm breeze was blowing. John suggested we order up a bottle of wine and sit in the pagoda overlooking the ocean. We sat and talked about life, philosophy, and our travels. We laughed about the bordello. It was without a doubt one of the most beautiful experiences of my life. I was sad to leave to go to bed, but we had an early start.

The consolidated audit we were doing had manufacturing aspects that John would handle, quality aspects that I

would handle, and an environmental safety portion that John would stay an extra day to do. We met the employees, many of whom we had been on global teleconferences and video conferences with, and set to work. Lunch at the company cafeteria was another opportunity to have real Thai food (HOT). By four p.m., I was finished my audit. I said my farewells and was told the driver would pick me up at reception.

When the van pulled up, I hopped in. I was disappointed that it wasn't the same driver who had picked me up from the airport and driven us to Rayong province. I tried to speak to this guy, but he didn't speak any English, so I settled back in my seat for the three-hour drive.

The driver received a call. It sounded like an angry exchange and as if he was getting orders of some kind. He agreed to whatever was being asked and hung up. Around the two-and-a-half-hour mark, I saw that there were traffic signs—left lanes to Bangkok, and others on the right to a really long name that started with F and had way too many consonants. The driver went right.

I was a bit alarmed, but having travelled in many places, I knew there are lots of times where there are multiple turnoffs, so I didn't think too much about it until the three-hour mark. Instead of seeing the tall buildings of Bangkok, we were driving out in the country, with nothing much in the way of stores or industry. It was then that I began to have some frightening thoughts. I knew the sex trade in Thailand was big business. How much would they pay for a 6'2" blond? By the three-hour-and-thirty-minute mark, I was really concerned. I had been thinking about what

to do—should I jump out of the vehicle and risk injury? Would he stop the vehicle and would there be an opportunity to call the original company driver? If I could figure out where I was, maybe he could come get me?

These were agonizing moments. Finally, at the four-hour mark, I began to see signs of civilization, and thirty minutes later, we were pulling up at the airport hotel. I was sweaty from fear, but as it turned out there had been a traffic accident, and so the driver had to go the long way around to avoid it.

As I went to check in at the hotel, a young man appeared, holding a suit bag. "Hi, I'm from James Fashion, would you like to try on your suit?" I had to admit, I hadn't actually thought I would receive it. But later, many of my colleagues told me that James Fashion was a top-notch, well-respected name in the Pacific. I smiled and tipped the young man and said I was really too sweaty to try anything on. I thanked him and took the bag with me to my room.

As I reflected on my visit to Thailand that night, I couldn't believe everything that had happened in just sixty hours. What a trip.

Indonesia,

2004

ALL THE SIGNS OF A disastrous trip were there. It began as part of a twenty-one-day jaunt in Asia-Pacific, covering seven countries, several of which require a visa to enter. To get the visa you have to send your passport to the first country, then when they have sent it back with your visa stamp, you send your passport to the next country, etc., until you have them all in time for your first flight. In theory, this works.

However, on the afternoon of my first flight (eight p.m. out of Toronto Pearson Airport), I was in the mail room of the chemical company where I was the global leader for Plastics Quality, anxiously inquiring if the courier had delivered something for me. Carol, the fiery redhead who

was in charge, replied in the negative. She could see that I was distressed. "What are you expecting?" she inquired.

"My passport with all the visa stamps, so I can leave tonight on a three-week Asian trip."

"Do you have a tracking number for the package?"

I did. Carol performed her computer-tracking wizardry and then delivered the bomb. "It's still in the main depot in Toronto. Not going to be picked up until first thing tomorrow."

I looked at my watch. It was two p.m. Toronto was a good three-hour drive—longer if traffic was bad. But I didn't have any other choice. "Call the depot. Find out if I can pick I up there. Find out how long they are open."

Carol, another woman of action, plowed the maze of apathy at the Toronto depot until she got someone on the line who would confirm that they were open until six p.m. and that I could pick up the package if I brought two pieces of ID.

The race was on. Fortunately, my luggage was already packed and in the car. Breaking all speed limits until I approached the Toronto parking lot (any part of Toronto that leads to downtown is a never-ending opportunity to crawl at ten km/hour, always when you have to be somewhere and you are racing against the clock). It was five-fifteen p.m. when I pulled up at the depot. Surprisingly, the pickup went off without a hitch and I began to feel like maybe all was well after all. The flight would board at seven-thirty p.m., and it was usually a half hour to the airport, but of course it was rush hour, so that turned into an hour and

I just made it through security and down to the gate in time to board the aircraft.

That was the start of the trip—and each day of the tour was full of crises, resolutions, impossible problems, and miraculous remedies. At one point, sitting in the airport lounge in Singapore, I was beginning to relax. I was at the halfway point of the trip, the audits of the quality control and analytical labs were going quite well, and my two young daughters seemed healthy and happy when they chattered to me on the phone.

As I boarded the flight from Singapore to Jakarta, I was seated next to the window. An Indonesian man was seated next to me. He was well dressed, and had what I call "wise eyes." You know, the kind that look like a well of experience and knowledge. He turned to me and said with surprise, "You are going to Jakarta?"

"Yes," I replied, with a warm smile.

"Alone?" he asked, with concern.

"Yes," I replied.

"Aren't you afraid?" he asked.

"Should I be afraid?" was my response.

His response was to hand me his business card. He looked earnestly into my eyes and said, "If you get into trouble, call me, and I will help you."

I thanked him and glanced at the card. He was the president of a bank in Indonesia.

"This is very nice of you to offer, but what makes you think I will need help, and why is the president of a bank offering help?"

His reply was chilling. "In my country we have a lot of trouble. Violence. Murders. If we don't fix it, the tourists will not come. If they don't come, our money will be devalued and they won't need a bank president."

We didn't exchange a lot more conversation on that flight. I was thinking back on the conversations about my Indonesia trip between the company travel agent and one of the plant managers, when it looked like we might not be able to get my visa in time. John, the plant manager had said, "Oh she can just tell them she's visiting friends. Then she doesn't need a visa. That's what I always do."

But the travel agent had said strongly, "No! She must not go to Indonesia if she doesn't have the business visa."

My thoughts were interrupted by the flight attendant, who had come to bring our customs declaration cards. As I was filling mine out, I noticed that there was a place that you had to declare any CDs, videos, etc., that you were bringing into the country.

As a singer/songwriter/musician, I had made a CD, and as part of this trip, was distributing copies to my employees in these various countries, per their request. But Christian CDs in a Muslim country can be an issue. However, I filled out the form with something to declare and as we exited the plane, I presented myself at the customs booth with the red "Something to Declare" sign.

Now, as a 6'2" blond woman, I am used to attracting attention, especially when I go to countries where the people are about half my size and girth. But I created a bit of a stir standing at the red sign, and several of the male attendants motioned me to the green sign area for "Nothing

to Declare." I held up my form and pointed to the red part where I had something to declare, but they just waved me on over to the green zone, checked my form, and allowed me through to pick up my bags.

It was at this point that I received an email changing the itinerary of the trip. Instead of Hong Kong after Indonesia, they now wanted me to go to Australia first, then Hong Kong. But in the days before electronic ticketing, this meant I had to go buy new tickets. So, with a considerable language barrier, I managed to buy the new tickets with my Visa credit card. (Oh, by the way, thanks Visa for deciding the transaction was an unusual one, blocking my card, and sending a letter to my house which I would not receive for another two weeks.)

So now, I approached the exit from the secured area, expecting to be picked up by the Merak plant manager, Jokro Hermann, whom I had never met, nor seen a photo of. But hey, how many tall blond girls were there looking to be picked up? As I waited inside the secured area, no one seemed to be there for me. So, I thought to myself, perhaps he is out at the curb waiting for me to come out. I exited the secure area and immediately the men were pressing in to grab me. "I take you, I take you, I take you," they each shouted.

But, like a well-seasoned, woman business traveller, who was basically twice their size, I sloughed them off and was pulling away when I heard a voice say, "Hi, I'm Jokro, I'm here for you." Gratefully, I was escorted to his car.

It was a gorgeous sunny day, and the place was a tropical paradise with lush trees and bushes. As we drove away from

the airport, there were many children begging in between the cars in traffic, some as young as four or five years old. It was sad to see, and Jokro said that many of their parents use them to beg as their business. He said he would take me for coffee because he had something he wanted to discuss.

As we sat down at a coffee shop and got our coffees, I could see he was becoming increasingly nervous. I said, "Jokro, if you have something you want to say, just say it. It will be OK."

He looked away uneasily, and then began, "Okay, at our company, it is very much like everywhere else. Respect for people, diversity, you can wear these clothes," (he motioned with a face registering distaste), "and it is fine at the company. But, in my country…" Then he paused. "Do you know the word 'chattel'?"

I said, "Yes, it means property."

He said, "Yes, this is you. You are like a chair, or a dog, or a hat. You can be owned here. Those guys at the airport who say 'I take you, I take you?' They take you home. They own you. I can't fix that. You don't have status here. So you must not leave the company driver, you must not leave the hotel until I come to pick you up, and it is not safe for you to be unescorted here. Oh, and one more thing. In my country, in our history, we were conquered by the Dutch. We really hate the Dutch. And you look very…Dutch."

Great. No status, heavy danger, and a visibly-hated target. This trip was turning out to be really so much fun. Afterwards, Jokro dropped me off at the hotel and said he would return at eight the next morning. The coolness of the air-conditioned hotel with its pure white furnishings was

a welcome sight. I freshened up, and then realizing it had been hours since I last ate, I went down to the restaurant. It was five p.m., but the restaurant apparently did not open until seven. Sensing my disappointment, the hostess said, "Well ma'am you can sit in the bar and they will serve you chicken wings if you like."

And so, to the bar I went. It was a beautiful bar with stools lining the carved wood bar, and a cathedral ceiling with one wall entirely a window looking out on a lush, tropical garden. A grand piano was positioned in the corner. I ordered a drink and some wings, and they slid down nicely. With nothing else to do for that evening, I ordered a glass of wine. Only the bartender and one waitress were in the room, until a piano player showed up and began to play Broadway favorites.

There was no one else in the place, so I started to sing to the melodies he was playing and my voice echoed beautifully in that place. The piano player was so excited. He was smiling and kept playing and I was singing, and it was great fun. Then, several couples came into the bar so I stopped singing. The bartender approached me and said "Ma'am, you have a beautiful voice. Are you willing to continue singing? My manager says if you will sing, all your drinks are free."

Great offer. And so I sang for about three hours in all as the sun set and the glowing orange rays filled the room.

The next morning, the company driver was there promptly at eight a.m., with a suit that was amazingly pressed in the humidity. At the company plant, I was pleased to meet many of those I had been on many phone

and video conferences with, and to start the audit of their quality systems and lab facilities.

At one point, I was set to tour the plant. I donned the necessary flame resistant Nomex clothing ;hard hat; safety glasses and safety boots and accompanied one of the operators outside. I was about to cross the field to the reactor area when he caught my arm and said "No, you can't cross there. Snakes."

I saw he was carrying a machete. "What is that for?" I asked.

"Chopping the snakes off the reactor structure and the analyzer boxes," he replied matter-of-factly. Indeed, due to the heat generated, there were huge snakes coiled around the bottom of the reactors and the analyzer boxes. As they bulged and writhed I could only think of Harrison Ford in Raiders of the Lost Ark when he said "Snakes. Why did it have to be snakes? " I watched in satisfaction as the operator hacked them to bits skillfully and in no time. After the tour we returned to the main building.

It was shortly after lunch when Jokro came to me and said, "You must leave right now."

I laughed and said, "I'm not finished my audit."

He said, "You must leave…we have trouble."

"Trouble? What kind of trouble?"

"Trouble." At this, he looked very uneasy.

"What kind of trouble?" I insisted.

"Many people have been killed in the north, and there is rioting and they are going to close the airport," he disclosed reluctantly.

Right. I picked up my belongings and was rushed to the car with the company driver. The drive was silent and tense. As we approached the airport, the road was lined with angry people with sticks and rocks, who pelted the car or shouted angrily at my little Dutch face showing out the window.

The military or police, I wasn't sure which, had control of the final yards to the airport doors. I thanked the driver, and raced into the terminal to check in. Once in the airline lounge, I poured a hefty drink and sat down to wait for the flight. The television was on, showing the rioting. Economic issues like food shortages and high unemployment had triggered racially motivated wars against the Chinese Indonesians.

Once I boarded my flight and we were in the air, I breathed a sigh of relief. I was on my way to Australia for the next adventure. I read in the newspaper that Indonesia was the place where you were most likely to be killed on business. Wish I'd read that before going.

Melbourne,

2004

THE NIGHTMARE OF JAKARTA WAS behind me. I was safe on a Quantas flight, a red-eye headed for Sydney and connecting to Melbourne. I arrived mid-morning, and was met by the company representative, Debra Sustar. Debra was an incredibly smart, feisty red-head, and she and I had had many good times on her previous visits to the U.S. She was to pick me up at the airport and take me on to the Altona facility.

It was a brilliantly sunny day, and we were in good cheer as we made our way to the plant. The day passed quickly, meeting the team, having lunch, and touring the facility. Before dropping me at my hotel, Debra offered to have me over for dinner.

Her house was a cozy bungalow with a large garden area. We entered through the back door into an L-shaped kitchen with bar stools at the end of the counter. She poured us drinks and we chatted as she busied herself around the kitchen preparing the meal. You can imagine my shock when a ten-pound bird landed on my shoulder. A kakapo, Debra told me, as if it was the most normal thing in the world for a bloody bird to be roaming freely about the house. Did I mention I have an aversion to birds?

Well, Lucy was apparently quite interested in the visitor from Canada. Put its beak near my face (AAAAAAAAAHHHHHHHH). Jumped from my shoulder to the counter. Nice. It was difficult to keep up with Debra's banter while I was freaking out!!!!!

Anyway, Lucy lost interest and disappeared. Thankfully, Debra put her in the cage during dinner.

By the time Debra dropped me at the hotel, I was ready to sleep. Thirty-eight hours awake will do that for you. The next day was the audit, and it took most of the day. A dinner with the team was planned for a restaurant close to Victoria Beach. I had some time before dinner to do some shopping downtown. I bought so many opals and so much gold that my credit card got cancelled.

Debra and her husband volunteered to take me to a wildlife park, on Saturday, so I could pet a wallaby. It was a lovely day, and I enjoyed very much strolling through the park. At one point we came upon a station where there was a koala bear. The attendant asked if I would like to hold it. I said yes, and took the furbaby into my arms. They are

just as cute up close as in the pictures. I had a photo taken holding this one before giving it back to the attendant.

We saw the many kangaroos, large and rather aggressive-looking. The wallabies, on the other hand, were sweet and quite tame in their willingness to approach. We had a barbeque for lunch, before starting back to drop me at the hotel. I was to fly out the next morning.

On the way back to the hotel, I was experiencing some gurgling in my lower regions. When we arrived, I said my farewells, hugged Debra, and returned to my room. I felt a strong urge to eliminate and made it to the bathroom in time to empty the contents of my bowels…which came out black. I felt ill and vomited. Fifteen minutes later, I again felt the urge to eliminate, and again, it was charcoal-black. By this time, I was weak and shaky.

The company had medical arrangements for us in many countries, and I looked for my global medical contact card. I found it, but there was nothing listed for Australia. The closest location listed was Hong Kong, my destination for tomorrow. Could I make it until then?

The night passed in a blur, on the toilet continually and so weak I could hardly make it back to the bed.

When morning dawned, I packed my things and lay on the bed. I was honestly unsure if I could survive the taxi ride to the airport without having an accident with my bowels. But I couldn't stay without medical attention. I used the bathroom one more time, and then made my way down to get a taxi (thank God for automatic check out).

En route to the airport, the gurgling began again.

The agonizing minutes passed until the taxi pulled up at the airport. I grabbed my luggage and made a beeline for the closest bathroom, making it just in the nick of time.

A little shaky on my feet, I checked my luggage in on Cathay Pacific (fortunately a partner with Air Canada, so I could access the executive lounge). I made it to the lounge and again made a beeline for the bathroom. Once finished I found a couch and lay down. I must have looked a wreck, because a young gentleman who was passing me said in a thick Australian accent, "Are you all right, mate? You look knackered."

"Fine. Rough night," I responded.

I took one final bathroom trip before I boarded. I wasn't sure how I would manage the nine-hour flight, but I thought if I just kept as still as possible, I could make it to Hong Kong and get some Imodium at the pharmacy across from the hotel. Then I got my period on top of all the other issues.

At the hotel that evening, I contacted my own doctor, since it was Monday morning back home. He advised that I likely had a parasite, (or cancer), and advised that if I checked into a hospital in Hong Kong, they might not let me leave to go home due to blood loss. (Apparently the black stool indicated blood loss.) His advice was to get on the next available flight and come straight to his office.

Don't ask how I showed up at the Tsing Yi office the next morning, completed the audit, had lunch, and returned to the airport. Pure adrenaline. The five-hour flight to Japan connecting to the nineteen-hour flight to Detroit seemed

like a lifetime. The Imodium had taken effect, and at least I was less concerned about that.

Upon arrival in Detroit, a limo was waiting to take me to the doctor. Three weeks of huge, horse-pill-like antibiotics later, I had recovered from the parasite that I think I picked up in Indonesia, but I suffered irritable bowel symptoms for quite some years thereafter.

Global travel sounds glamourous, but this experience, combined with the malaria and dengue fever I got in South America, and the walking pneumonia I had three times, demonstrates that it can take a toll on your health. It was not a great ending to a very enjoyable time in Australia. I hope to return there and re-do it some day.

Hong Kong,

2005

THERE WAS A RHYTHM TO Hong Kong. The "Hong Kong shuffle," they called it. People like ants, walking in the streets but never colliding. Buildings, stretching up high to the skies, with a constant assault on peripheral vision from flashing signs and lights.

The first time I went I was curious, but with some apprehension. Hong Kong was under British Rule then. The nineteen-hour flight from Detroit to Nagasaki, Japan, connecting to another five-hour flight to Hong Kong was a bit of marathon, which could only be completed with a lot of alcohol and a few cold tablets. Northwest Airlines flew this, the longest flight duration of the time. Upon arrival, I collected my bags and looked at my options: a metro or a

taxi. Having learned my lesson on metros in Paris, I opted for the cab.

My eyes soaked up the sights and sounds as we travelled downtown to the Park Lane Hotel. Once checked in, I settled in for a good sleep. The following morning, one of my team picked me up at the hotel for our drive to the manufacturing facility at Tsing Yi. It was a great day meeting all of my direct reports and even having Pizza Hut (with some rather wild Chinese toppings).

After work, my colleague, Angus Chen, took me back to the hotel on the subway. Standing in the center of a subway car was quite a sight, with a sea of black-haired heads that came up to my underarms in all directions, each one with a cell phone. I felt like a giant there, and people would often stare at my fairness as I walked about. We had some time before we got picked up for the group dinner, so Angus showed me that a short walk from my hotel was Causeway Bay, with some great shopping. I bought lots of clothes and presents there, which we dropped at the hotel before going on to dinner at Victoria Peak...We got to ride the cable car, which was a treat.

It was hard to keep straight exactly which part of Hong Kong I was in over the next days, but several memories stick with me. One night, the group was taken down to the harbour queue, where vendors had seafood in large aquariums for individual sale. They would put them in plastic bags, which we were going to take to a restaurant to have the fish prepared. In one of the aquariums there were these finger-like things wiggling back and forth in the water. I

suggested to Angus that we should get some of these. With a big smile he agreed and had some bagged up.

We all hopped into the van and arrived at this pristine restaurant with pretty pink tablecloths. At the door we handed in the bag of glop, and soon were sitting with our drinks, eagerly awaiting dinner. I kept a careful watch for the finger things and soon enough they came out. The fingers had split open, and inside each one was something that looked like a wiggly worm. It was all done in some kind of brown sauce.

Since I was the guest, I was motioned to try it first. I said, "Well, before I try this, I need to know what it is."

There was a lot of back and forth in Chinese around the table, until finally Angus remarked, "You don't really have a word in English for this—it's like a sea creature."

Great. Just what I was hoping to hear. I tentatively took the wormy thing in my mouth. It had the consistency of a dime-store rubber snake and a similar taste. I added it to the other many culinary experiences that I wouldn't want to repeat.

One thing my travels in Asia Pacific had taught me was to be on my guard when I was travelling alone. Where previously I would have struck up conversations with random strangers and had many fun adventures that way, I was such a visible tall-and-blond target, that I became keenly aware of the dangers. Back at home, my kids had become black belts in Tae Kwon Do. In the beginning, I just chauffeured them to and fro, drank coffee, and ate doughnuts. But eventually I thought about joining in for the exercise. The kids would have none of it. This was their thing, not mine. But

they changed their minds once they were black belts. They liked having me bow to them. I kept on with Tae Kwon Do until I got to the place where the next step was to get my black belt. By then my eldest was the Junior A champion for Canada in the lightweight division. I was definitely not a lightweight, but was pleased with my accomplishment, and this somewhat eased my fears when travelling alone.

When I next returned to Hong Kong, it was under the rule of communist China. I wasn't sure what to expect, but it was the same flight on Northwest, the same ride from the airport to the Park Lane hotel, and the same group working at the plant.

On the last night I was there, there was no group dinner planned, so I made plans to return to the market at Causeway Bay to buy some more great deals. However, as I was walking there, I must have taken a wrong turn. Soon I was coming down an unfamiliar narrow alley. At the end of the alley were three shady-looking men. They began to rush toward me, and I knew it was with ill intent.

When the first one came at me, I tiger-pawed him to the larynx. He dropped to the ground. The second one approached and I side-kicked him as hard as I could. He stumbled back, losing his balance. The third guy, in total surprise, turned around and ran off down another alley way.

I didn't wait to see what would happen. I just ran as fast as I could back the way I came, and once on the crowded street again, I felt better. The adrenaline was still racing through me, and it was hours after I returned to the hotel and quite a bit of wine before I was calm again.

Had I killed the first guy? I didn't know. **Should I call the police?** Well, all I'm saying is that I saw Richard Gere in **Red Corner**, and the thoughts of me in a Chinese prison were not happy thoughts. I packed my bags for my morning flight and arrived at the airport in good time.

When I went to check my bags in, the Northwest attendant would not check me in. She motioned for me to get into a line of people with their luggage who were going before a lineup of what looked to be Chinese police or military (it was hard to tell from their uniforms). I tried to hear what questions were being asked. Were they looking for a 6'2" blond who had killed a Chinese citizen?

When I made it to the front of the line, a very skeptical-looking officer asked me the purpose of my visit. "Business," I said.

He looked at my passport and then stared intently into my eyes and said, "Do you have anything you want to declare?"

Was this the time? Should I mention the incident? Did he already know? But all the good cop shows say, "Deny, deny, deny," so I looked him right back into his eyes and said, "No, sir." They then opened my luggage and went through it as though with a fine-tooth comb. I wondered what they were looking for.

Whatever it was, they didn't find it, and I was allowed to proceed to security and to the gate.

By the time all the passengers were put through this interrogation, our flight was delayed an hour and a half. I was becoming concerned about cancellation. That would be just what I needed—to be here for another day if the police

were looking for a killer. Also, my connection in Japan had only a two-hour cushion.

I was nothing but relieved when they boarded us.

I'm not sure why that when you are at your most frazzled seems to be the time when babies are seated next to you in business class. Now let me say for the record that I do not hate babies, but I am philosophically opposed to them sitting in business class. They are not doing business, other than in their diapers, and they keep those who are trying to do business from doing it. This little dolly of a mother was seated with her baby and her two-year-old. An aisle separated us, but it was not enough. From the time they were seated, this little baby started screaming—and let me tell you, this kid had lungs. Parents, any of you who get a kid like this will never need a baby monitor. The flight attendant, trying to appease me, asked if I would like something to drink. I asked for two rum and cokes.

The first one I put down before they even closed the doors to the airplane. The second one I put down in celebration of escaping the Chinese authorities. But the kid's screaming, which was loud even before we were airborne, drowned out the sound of the engines on take-off. That's impressive screaming. When the flight attendant came by, I asked for another drink. She brought me two. By the time I got to the bottom of those, they were serving our hot nuts. She motioned to my drink and said, "Another?"

I responded, "Yes, and if this one doesn't work on me, the next one will be for the baby."

She laughed. Didn't happen though, and that bloody child screamed all the way to Japan.

I was the first one out the door…As I was coming out of the gate, I heard the final boarding announcement for my flight to Detroit. I ran, I jumped, I got through security and arrived just in time—last one in before the doors closed.

Now drinks in the serenity of no baby seemed even sweeter. Plus, what I had learned from the flight attendants was that earlier that day a contractor in Detroit, who had been doing construction, had cut into the lines that connected the world-wide computers.

This is why they'd had to do manual check-ins and inspections in Hong Kong. It had nothing to do with murder, and everything to do with what the utility companies refer to as "calling before you dig".

That was the last time I ever went to Hong Kong—just in case I really did kill that guy.

Aruba

2010

SOMETIMES YOU JUST NEED A Caribbean vacation. It had been a tough year in my family. My brother Bob had gotten divorced and was living in an apartment in Detroit. He had left his prior job and was not happy in the new one. My sister Cathie had undergone seven chemotherapy treatments for breast cancer and another fifteen radiation treatments. She had made her bucket list, and a Caribbean vacation was on it. Unfortunately, with no friends and no money, there was a slim chance it would happen. My brother similarly had no funds to spare. My husband, as usual, was not in favour of me going on any trips. However, these are the times when you have to be there for your siblings.

And so it was that Bob, Cathie, and I were headed to Aruba, and we gathered early in the morning at the Detroit

airport. The flight was enjoyable, and we landed, got our transportation, and arrived at the resort by lunch time. All three of us were staying in the same room at the Riu Palace. Lunch was a buffet affair. We scoped out the place after lunch, signed up for dinner at six p.m. at the steak restaurant, donned bathing suits, and headed for the pool.

It was a typical resort afternoon: pool aerobics, free-flowing drinks, hot sun. By four in the afternoon, we were standing in the swim-up bar, drinking with a number of the other guests. My brother's business took him to Charlotte, North Carolina quite a bit, and there was a newlywed couple from there that he hit it off with. My sister went back to the room to have a nap before dinner.

Kyle (one of the newlyweds) was in the process of trying to get my brother Bob to squeeze a lime in his eye and do a tequila shot—part of something known colloquially as a "tequila suicide."

Bob said, "What d'ya think?"

I said, "Take the shot of tequila, but don't put a lime in your eye. That'll hurt."

Of course, with too much alcohol poor judgement prevailed; he took the shot, put the lime to his eye, and immediately had to flush it with pool-bar water. Then he got out the pool to go to the bathroom. We all had a good laugh and went back to partying.

Some of the others in the group had been across the street to Senior Frog's and were all full of info about a girl named Natalie who had gone missing from there and been murdered some years before. Everyone participated in

adding their info to the CSI session happening at the swim up bar.

It was after five when the crowd started to thin out. I looked around and didn't see my brother. I didn't see the newlyweds, either. I thought maybe Bob had gone back to their room for drinks. I didn't worry too much. He was a big boy and we had arranged to meet for dinner at six.

I returned to our room where Cathie was just getting up from her nap. "Have you seen Bob?" I asked.

"No," she replied. "I thought he was with you at the pool."

We got ready for dinner. By 5:50 p.m., we were a bit concerned. Everyone in our family is a stickler for punctuality, and Bob was no exception. Finally, we decided we'd meet him at the restaurant. We showed up. No Bob.

The maître d' seated us at a lovely table overlooking the beach. We were hungry, so we ordered. Yet as the moments passed and still Bob did not appear, we began to worry.

We tried to take our minds off of it by sharing stories from the years since we had drifted apart as sisters. It was a chance for me to share the marital problems I was going through and for her to unload about the cancer treatment. Still, as the minutes ticked by, our missing brother was the elephant in the room.

By the time we finished dinner, we decided to search the resort and the beach. No Bob.

By eight-thirty that night, we went to the front desk to report that our brother had gone missing. They informed us that they couldn't do a missing-persons report until he had been missing a full twenty-four hours.

We were pretty silent as we returned to the room. Cathie was tired, still recovering from her treatments. I decided to have a couple drinks. At nine-thirty, the door opened and Bob walked into the room.

He was burnt red like a lobster, and he fell down on his bed.

"Are you OK?" I said.

He seemed disoriented. I made him drink water, convinced he was dehydrated.

After a bit, he began to tell the tale of what had occurred. When the lime had hit his eye, he said it was like his eye was on fire. After he'd flushed it with the pool water, he had decided to go to the bathroom to try to flush it out further.

After cleaning his eye, he'd gone into one of the stalls. They were the fancy ones, with the heavy doors and the locks on the door. He had no sooner finished his business, when he felt woozy and he passed out in the stall.

When he'd come to, he was so weak and dehydrated he couldn't get up. He tried to call out for help, but no one responded. (What he didn't know is that they closed that part of the hotel up at four-thirty p.m., and didn't re-open it until breakfast.) It was about another hour by the time he could pull himself up enough to sit on the toilet. It was another long while before he had the strength to stand and try to get out of that place. By the time he'd stumbled back to the room, he was still pretty weak.

That was day one.

Day two dawned, another bright sunny day. Bob seemed well recovered, and Cathie was glad to see him alive. We decided to have a beach day, so we made our way there after

breakfast. The day passed without incident until Cathie, who was not much of a sun worshipper, decided to go for a walk.

Bob and I had returned to the room to get ready for dinner, when Cathie came in. She had put her foot down on some kind of grate that broke, and she had slit her heel. I had brought a first aid kit, and was able to disinfect and provide the necessary bandages.

We dressed and went to the Japanese restaurant for dinner. Other than the couple behind us with their toddler who screamed throughout the meal, it was fine. I don't know why people think that other people want to listen to their screaming kids when on vacation, nor why they don't take them out when they scream. Lack of manners, I guess.

On day three, we had planned to go on a Jeep tour of the inner island. The day was cloudy, with many dark, ominous clouds on the horizon. When the shuttle arrived at the tour start, we were paired up with another Canadian couple. We refused the option to drive ourselves, and were assigned a driver named Christian. The Jeep had a cloth roof to it, but was open on all sides.

By the time we started into the interior, it began to rain. We continued on, but the rain turned into a cloudburst. Later, we found out that a hurricane was passing this tip of the island and had brought this, for the island, very unusual weather.

We sat, shivering and soaking wet, as we traversed huge mud ruts while climbing up a mountainside. I looked at my sister and thought to myself, **I've just killed my sister. She's going to catch pneumonia from this.**

It had stopped raining by the time we crested the mountain, but unfortunately, the rivulets from the downpour had caused mud slides that were quite treacherous to drive through. Christian, our driver, seemed unfazed, and we assumed that he had done this plenty of times. His calm helped calm us.

We were unable to do the "lunch swim" since the ocean was wild and the waves high. We ate our boxed lunches as we sat in our soggy clothes. When you are cold and uncomfortable, it is amazing how focused you become on yourself. I know we visited a store and a church, but I don't remember too much more about the tour. I just remember being really glad to return to the resort. We had hot showers and drinks in the bar before dining at the Italian restaurant.

It was a great dinner. We had recovered from the harrowing experience of the day, and joked around like we had as children. We remembered and shared funny situations from our childhood. After dinner, we decided to have an early night.

The next morning (day four) we were booked to go on a snorkelling catamaran. We had our breakfast and were at the dock promptly for nine-thirty a.m. (the scheduled show-up time). The next hour was a cluster of other people not showing up until ten-thirty. Since all the good seats were taken by then, there were a lot of loud and unhappy back-of-the-boaters.

Without further ado, we set off for a great cruise. It was a perfect day—sun, sea, and rum punch! My sister did a great job snorkelling, but she tired easily, so I helped her back to the boat and stayed with her. The time passed easily, with

a fine lunch, and enough rum punch to take the edge off any day.

We returned in time for dinner, which we decided would be at the buffet. Life at home seemed far away, and we were all in good spirits.

After dinner, Cathie was tired and wanted to lie down, so Bob and I went to the bar to play some cards. There was a piano player playing some classic Broadway tunes. Of course, I sang. Of course, Bob was embarrassed. Of course, I continued anyway. At ten p.m., I decided to turn in. Bob was going to go for a walk before bed.

At eleven, I was awakened by Bob coming into the room, headed for the bathroom. He called out, "Marilyn, come in here right now and don't freak out."

I jumped up and went into the bathroom. Bob had been wearing these Don Johnson-style white pants. The pants were around his ankles and there was blood gushing over them from a gaping wound on his leg.

"What happened?" I asked, grabbing a washcloth and applying pressure to the wound.

"I was taking a walk," he said, "and I came to this short wall, and I thought I would just step over it instead of walking all the way around, but my leg got caught on it and I ripped it."

"Well, that needs stiches," I exclaimed, after examining it further.

"No, it doesn't," he insisted. "You've got your first aid kit. Tape it and bandage it and it will be fine."

I was skeptical, but I did as he asked and we got him into bed. I cleaned up the blood with towels. God only knew

what our room maid was thinking. Bloodstained towels from yesterday's heel event, and now more bloodshed.

Bob turned over in bed and re-opened the wound. Now we had bloody sheets to go with the towels. It was starting to look like a massacre. I threw on clothes, got Bob shorts and a shirt, and said, "OK you, let's go to Emergency."

We took a taxi to the emergency room, being careful to soak the blood in the towel and not in the taxi. Upon arrival, they took Bob right in, and I took my seat in the waiting room.

There was no one else in the waiting room, but based on my experiences at home I settled in for what I thought would be a several-hour ordeal. You can imagine my surprise when Bob returned twenty minutes later, stitched up, with the paperwork for his HMO. For $128 on the Mastercard, we were out of there. We need a system like that in Canada.

The next morning, over breakfast, I read the two of them the riot act. "Now look," I said. "It's day five, and you've pretty much used up my first aid kit. I'm supposed to be the irresponsible one, so you guys need to be careful!"

It was a bit overcast so we decided to go into town shopping, a harmless-enough activity. We looked around, bought some souvenirs, and had a nice lunch in town. It was raining by the time we returned to the resort, so we read books, checked emails and Facebook, and played cards until it was dinner. We went back to the steak house, since Bob had missed it the first night. We had a great meal together and decided to go to the disco bar to check out the action there. It was karaoke night, which suited me fine, but

that wasn't the ticket for Bob and Cathie. So, we returned to our room and sat on the balcony. It had stopped raining.

The next morning, Cathie wanted to sleep in. Bob and I went to breakfast. The day was a bit overcast. We changed into bathing suits and went down to the pool area. Bob couldn't go into the pool with his stitches, but it didn't matter, because it was a bit of a cool day. Cathie appeared in time for lunch. Afterwards, she returned to her book, Bob went to the casino, and I persisted at the pool until it started to rain. I got changed and went to join Bob at the casino. We went from there to the sports bar, where we played cards until dinner. We settled on the buffet for our last dinner. They had everything.

After dinner we had a walk (no injuries). We returned to the room for drinks on the balcony. The evening was beautiful and we sat, looking over the ocean, ready to return to our lives the next day. Our flight out was supposed to be after dinner time. We lazed by the pool until the shuttle came to take us to the airport. The flight was delayed, so we had dinner at the airport restaurant.

It was one of those travel experiences that goes from bad to worse. By the time our flight got into Detroit, it was eleven at night, and Cathie was exhausted. Bob got his luggage, we said our goodbyes, and continued to wait for our luggage. Cathie's didn't arrive. As a traveller who has been flying for more than thirty years, sometimes luggage doesn't show up, but I've never lost it permanently. So, it is easier for me to remain calm. As we stood in the unbelievably slow line at the Delta counter, my sister lost it, and started to cry.

I tried to comfort her by telling her that they would be able to fly it up to her in London, Ontario when they found it, but it was then that she told me she had put her cancer medications in it. This is the very reason why airlines tell you to keep your medications with you. It wouldn't have been helpful to her to say that just then, so we just did the painful exercise of filling out the forms and then got to my car.

We got on the highway and were sailing along, calling ahead to Cathie's partner to let him know we were on the way. He was going to pick her up at my place, and he comforted her by telling her that she had spare medications at home and would be fine.

I had started to feel better when all of a sudden, I-94 was closed at French Road. No explanation, just everyone ushered off the ramp. And no detour signs. I turned left to take the overpass over the highway to the other side, and then I took a right. It was dark—midnight in the hood of Detroit. Not the place for two white girls in an SUV for sure. Cathie again began to freak out about how we were lost and she was scared.

Calmly, I pointed to the highway, which, although empty, was now on our right-hand side. I said, "Cathie, relax. I'm going to drive down this road parallel to the highway until I see that it is open again, and then I'm going to get on it." And that is what we did. The rest of the trip home was uneventful.

Bob eventually got his stitches out, and this became the first of many joint vacations he was injured on. Cathie must

not have been too traumatized, because she let me take her on another Caribbean vacation to Antigua.

I stopped at Aruba on a singles cruise a few years later. While all the other thousands of cruisers went to one destination, I talked my friend and the two guys we were hanging with into spending the day at the Riu Palace beach. For sixty bucks, we got four lounge chairs, an umbrella, and a bucket of beer. We had a beautiful afternoon there, swimming in the pristine ocean, and enjoying the sunshine on a non-crowded beach. Aruba still holds top spot in my Caribbean vacation experiences.

Restoule

2011

MY (NOW) EX-HUSBAND GLENN WAS accident prone. For the entire marriage it was always something— broken ribs, electrocution, ripped anterior cruciate ligament, spiral fracture, you name it. On one of these many hospital adventures, he was chatting with a nurse about cottage destinations. She had a cottage up in a place called Restoule, Ontario, and raved about what a gorgeous place it was. In no time, he was bound and determined for us to have a family vacation there.

We searched the internet and found a cottage to rent for a reasonable price. Buyer beware! Our daughters were sixteen and eighteen, and about the last thing on the planet that they wanted to do was go on a family vacation. But he was determined. "It'll be great!" he exclaimed. So we

packed up, jumped into the Durango, and began the five-hour drive up there.

When we lost internet capability, enthusiasm for the trip definitely faded for the girls. When we started down gravel roads far enough away from a hospital to give me concern about one of us bleeding out in an accident, I began to have my doubts. But when we arrived at the "rustic" cabin—I mean, almost worse than cabins when I was a camp counsellor, disappointment set in.

Oh well. It was a beautiful sunny day, and the cottage overlooked a lake, and had a dock with a couple of colourful Adirondack chairs on it. The landlord showed up with the canoe and kayak we had rented and the keys for the place. Once he left, we brought our stuff in to check out the place. It was definitely a bare-bones affair, with three bedrooms, a living room, a kitchen, and a screened-in porch.

I unpacked the cooler and made dinner while the rest settled in. After dinner, we decided to take a walk. Other than the cottage next door, which looked uninhabited, there was nothing but gravel road and forest as far as you could walk. We returned to the cabin, and my husband started a fire in the fire pit. We sat and chatted and watched the sun set over the lake, like something out of **On Golden Pond**. Once the sun had set, the mosquitos came out in fierce numbers and we retreated to the cabin. We had brought a few movies on DVD, and there was a TV and DVD player, so we watched a movie until it was bedtime.

I was restless, so I took a glass of white wine out onto the screened deck. There was likely a hole in the screen somewhere, because the occasional whining of a buzzing

mosquito in my ear caused me to flap my arms and spill my wine. There were the sounds of crickets and frogs and night creatures, and the soft ripple of wind across the water, silhouetted in moonlight. I retired to bed.

The next morning, we were awakened by birds. Lots of birds. Loud birds. Like me, one of my daughters also has an aversion to birds, so we were not impressed. After breakfast, the kids wanted to take the kayak and canoe out. We donned bathing suits and headed down to the dock.

The water looked a bit murky and the kids were not too sure about the situation. We got them placed in the boats, along with my husband. I settled back to catch some rays. In no time, I was overheating and ready for a dip.

I jumped into the water…and my feet sunk into slime, thick and black and awful. I quickly climbed out to discover I was covered in black bits of slime from head to toe. Disgusted, I returned to the cabin to shower off.

The shower was tiny. In fact, it was so small I could not turn around in it, nor could I bend my head down to see if I had got all the slime off. I had to basically run my hands over all parts to determine if the dirt had been removed. I stepped out, rinsed out my bathing suit, got a new one, and returned to the dock just in time to see my oldest daughter tipping out of the boat into the same black slime. Nice. She ended up with impetigo from the incident. Needless to say, there was not a lot of swimming on this trip.

After lunch, we walked in the opposite direction. Still nothing but gravel and forest. We barbequed for dinner and had another fire. By this time, we had nothing much to say, and the kids were freaking out that they had no internet

service. The DVD movie was lame, and the kids went to bed by nine. My husband and I were fighting by then, so he went to bed and I repeated the wine-on-the-screened-porch experience.

The next morning, the kids insisted we return to civilization. We decided to take them to Science North in Sudbury. My husband had considered moving to Sudbury for work, and so it offered a chance for him to check in with the pipefitters local there. After finding the local and having a brief chat with the folks there, we went on to Science North.

There was a lot to see, from the Butterfly Gallery, to the space floor, to a great IMAX presentation on planes (my father-in-law had been a bush pilot, so Glenn loved this part), and the World Records themes. We wandered from floor to floor until hunger drove us to stop.

We found a place nearby called "Respect is Burning," which pretty well represented the sentiments of all present. The food was great and abundant, so that by the time we returned to the cabin, no one was really very hungry. We lit another fire, and eventually toasted hotdogs and marshmallows before the vicious mosquitoes caused us to again retreat to the cabin.

Everyone hit the sack early (I repeated the wine-and-screened-deck routine). When morning dawned, the kids were again wanting civilization and internet service. We drove to North Bay, a scenic tour. After a bit of shopping at the Northgate Center and a nice lunch at Average Joe's (which I thought was above average, just sayin') and we returned to our cabin.

We sat around on the dock. The kids took the boats out again, being careful not to fall in the murky water). My husband, who was by nature a germophobe, continued to complain about the venue. I went off to make dinner.

The mood at dinner was not good. The kids were unhappy about the lack of internet. My husband was unhappy about the cabin, the lake, and the lack of anything to do. I was just unhappy. We decided to leave early and return home. I had one more evening of wine and screened-porch silence before the next morning, when we were up, packed and on the road by nine a.m.

Moral of the story—recommendations for vacations from nurses taken while you are sedated are likely not as advertised.

CHAPTER 19

Israel

2016

NOTHING ENHANCES THE TRAVEL EXPERI-
ENCE like pain from an injury. In 2015, while running
for federal parliament, I door knocked about 20,000
doors as part of the campaign. Once elected as member
of Parliament, I flew to Ottawa three weeks out of four to
execute my parliamentary duties. Since I had no car there,
I ended up walking everywhere on Ottawa's cement and
bricked walkways in what I will just define as " bad shoes."
You know: heels that are meant for walking less than a
block in the whole day, boots with flat bottoms that were so
in style, and dress shoes that were not meant for the mara-
thon life of an MP.

And so it was that I ended up with a condition called
plantar fasciitis—a very painful tearing of muscles in your

feet that can take years to repair. In fact, my doctor told me I would be in running shoes for three years. Seriously? Under the scrutiny of the media fashion police? I received the news in June of 2016 after Parliament had adjourned, when I was schedule for a parliamentary trip to Israel.

It was a group of parliamentarians, twelve in all, that were to receive a tour from the Knesset, to the Palestinian areas, from Jerusalem to the Golan Heights, from Tel Aviv to Joppa. Religious sites and history, briefings from the Israeli military, and interaction with the world's best start-up economy were on the docket. It was an exciting opportunity…right up until my feet let me down.

Each day, even walking in running shoes was like continually stepping on a knife. I didn't know how I would survive this trip, but it was not an opportunity that could be cancelled. It was an honour to be asked.

The MPs and our guide, David Cooper, met at the Toronto Airport and gathered in the lounge until we were all collected and ready to board the flight to Jerusalem. It was a chance for MPs from all parties to get to know each other better, without partisanship rearing its ugly head. The flight was uneventful. We arrived, collected baggage, exited customs, and boarded the air-conditioned bus that would be our tour home for the week.

The first stop was lunch at an outdoor restaurant. It was about 38°C, and I was more about the air-conditioned bus than the great sweltering outdoors. Oh, and this was the beginning of the hummus. Yes. Puree some chickpeas and you have a staple that Israel loves to dip into every day. Fun fact. Eighty percent of Canada's chickpeas grown in

Saskatchewan are exported to Israel. Did I mention I hate chickpeas? The only thing that will make hummus better is if you chop up so much other stuff that tastes better into it (you pick: garlic, red, peppers, whatever), that you can hide the taste of the chickpeas.

Anyhow, the hummus appeared, with pitas for dipping and I wasn't sure if there would be anything else. There was water to drink, and then eventually, chicken and vegetables showed up. After the lunch, we were introduced to Michael. He was to be our guide. He had a delightful German accent, and was purportedly one of the best guides for Israeli religious sites in existence.

Our bags were taken to the hotel, where we were to check in and meet in the lobby at one p.m. for the beginning of our tour. I freshened up, jumped into shorts, cool clothing and sunscreen, and of course—running shoes.

Thus began a four-hour walking tour of Jerusalem: the gates, the markets, and through the various quarters of the city. After an hour in the heat, we were walking through the fourteen stations of the cross and up the Via Dolorosa and all I could think was, I'm being crucified from the feet up. Oh the pain and the heat. Then the tour of the Church of the Sepulchre. We ended up at the wailing wall and I can tell you it was no trouble at all to wail. Mercifully, after the wall, my prayers were answered and we returned to our air-conditioned rooms to get ready for dinner.

Hummus appeared again one hour before anything else edible appeared. I wondered if chickpeas were toxic in large quantities, but it appeared everyone around me was fine.

After a nightcap overlooking the city with the MPs, it was bliss to fall into a deep sleep.

The second day dawned, with a chance to visit the Knesset. Israel has an interesting democracy. With 120 seats, and over thirty parties running, the winning party needs to form a coalition government in order to accomplish anything. We were toured through their parliament, before a lunch with parliamentarians, and proceeded then to the Holocaust Museum. This was a somber part of the trip. No one could go through that museum, see the evil that men do, and emerge unchanged.

We continued onto the bus to visit a Palestinian territory, "Area C." As we crossed from the well-tended farmland and houses on the Israeli side, I noticed a distinct difference as we entered Area C. Garbage littered the streets, and the homes were unkempt. We were taken to a briefing from the Palestinian authorities. Not to get political in the middle of a travel memoir, but the average age of the |Palestinians was eighteen, with fifty percent unemployment. Not a recipe for peace!

It was a quiet ride then to travel for a surprise activity—travelling to ride dune buggies in the desert where Christ is said to have spent forty days in the wilderness. The view of the desert and the valley below where Jericho could be seen was amazing, as was the sunset, and fortunately the ride was not a repeat of the Arubian disaster. After the ride, dinner at a nearby restaurant had been arranged.

Here, the hummus was served with other things, and so I was able to avoid it altogether. Dinner with various well-spiced meats and lovely Israeli wines went on until long

after the sun had gone down. Back to our hotel we went on our beloved tour bus, and everyone was tired right out.

The next morning dawned bright and sunny. We drove out to Masada, the great fortress of King Herod. It was a hot day, nearly 40°C, and my feet were already screaming from the previous walking tours. We took the cable cars up to the desert fortress and began the tour. After two hours of walking around, I stumbled down a hill and scraped my knee open. Fortunately, I had brought the beloved first aid kit and was able to apply Polysporin and BandAids. The guides were quite relieved.

After the tour, we proceeded to a hotel on the Dead Sea. After our lunch, which was waiting for us when we arrived, we had arranged to be able to cover ourselves in mud (God I hope there are no pictures) and swim in the Dead Sea.

As I applied the mud to my bikini-clad body, I noted how it stung when it contacted my open wound. That was nothing compared to the effect of entering the Dead Sea. I have heard salt is good for a wound, but they don't describe the pain associated. After purchasing souvenirs from the day, we continued on our travels.

We continued touring to the River Jordan, to dip our toes, and to see the Mount of Beatitudes. We saw Capernaum, where Christ began his preaching. We saw the house of the mother of Peter, the famous disciple. We continued on to the Sea of Galilee, where the Church of the Primacy of St. Peter was seen. Comradery was developing amongst the MPs, and we eagerly absorbed the history that Michael was able to sprinkle upon us at every location.

We continued north to the Golan Heights, where we stayed at a Kibbutz. It was a bit disturbing when David Cooper announced, "Now, if you are going for a run tonight, go that way." He pointed out a direction with his finger.

I, of course, needed to know why. He said because two kilometres the other way was the Syrian border, where thirty different factions were at war. Lovely.

Dinner was hearty fare. By this time, when the hummus arrived with the pita, I dug right in. I was starting to actually like the stuff. Possibly because there didn't seem to be anything else that arrived first when I was ravenous.

The next morning, first thing, we packed up and the bus took us to our debrief with an Israeli commander on the Heights. We were taken out to the furthermost outpost of the Israeli Army, and given a summary of the situation. We could hear shelling in the distance, and since we were only one kilometre away from the border, the commander gave us a rundown of the various enemy groups, from Hezbollah in the north, to ISIS in the south, and Al Qaeda in the middle with a mix of various other tribal wars.

I asked, "Are we quite safe here?" Knowing that I, as the tallest, blondest infidel in the group would be the first to be sniped. The Liberal MPs were busy tweeting away their joy at the "Canadian delegation of MPs getting a de-brief from the Israeli commander on the Golan Heights outpost." Nothing like telling the enemy right where to shoot you.

The commander replied, "Well, normally they don't shoot this way, because if the bullets cross our boundary we will retaliate."

Normally? I'm thinking. Doesn't inspire a warm, safe feeling.

We departed from that base and were taken to the border with Lebanon, 500 feet from where Hezbollah fighters had rocket launchers in the houses aimed at Israel. Again, we sat blissfully in the sun for a half hour, unsure of whether rockets would fly or not.

The rest of the day was a journey to Tel-Aviv, a beautiful, oceanside gem, with white sandy beaches and all of the advantages of a cosmopolitan paradise. We arrived in time to freshen up for a beautiful cocktail hour with the Canadian Ambassador to Israel, on a condo overlooking the ocean. Sun sparkled off the water, and the sea air was fresh.

We boarded the bus, which took us to a location where three weeks earlier, there had been a terrorist attack. One hopes that lightning doesn't strike twice in the same place. We had a chance to do wine tasting in a wine cellar that served appetizers. Each MP was given a credit card with a certain limit. We were allowed to take samples from Israeli wines that were grouped into reds and whites, and in geographical order from north to south. All the wines were fantastic!

The next morning consisted of briefings with those involved in Israeli start-up companies, clusters to drive economic development, and a briefing from the Israeli Airforce. From there, we toured Joppa, before ascending to a rooftop for a dinner overlooking the surrounding city. This was a magical night, with the perfection of the delicately-seasoned beef, fish, and vegetable dishes

complementing the warm air, wine and the company of a group well-harmonized. It was the last night of the tour and well celebrated.

I was staying by myself and returning to Jerusalem to see a few other sights. The bus driver drove me, alone, to Jerusalem, and dropped me to the hotel there. The bus driver (the married bus driver) was interested in staying and having drinks, but knowing he was interested in more than drinks, I sent him on his way. I treated myself to pizza and wine for lunch, before making a return to the market to buy souvenirs.

The next morning I was scheduled for a tour, which began at the top of the Mount of Olives. There, in the gift shop, I acquired a beautiful, rose-gold Jerusalem cross, set in the center with an original mite, the smallest coin ever minted (recall the story of the widow's mite and you may see the significance!) From there, the group travelled down the mountain to the Pater Noster church, where the Lord's prayer is printed in every language on stone tablets throughout the garden. After touring the garden, we entered the inner church building, where the English version was. The guide asked if anyone could read it. I replied, "I can sing it," and I proceeded to sing it acapella in the echoey chamber. There were many with tears in their eyes as I finished.

Onward to the Garden of Gethsemane and then to the actual Garden Tomb. It was a pensive crowd, that remained so on the return journey. Once at my hotel, I made for the pool on the roof. After a period of relaxation and swimming, I decided to visit a restaurant across the street from my hotel. As I sat with my white wine and perfectly

grilled St. Peters Fish (tilapia), I reflected on the number of dinners I had eaten across the globe—some with company and some quite alone. I had gotten used to the odd stares of people when dining alone, but this particular evening, for whatever reason, it bothered me more than it ever had.

I returned to my room to sleep and was up early for the Bethlehem tour. This tour is a bit tricky because Bethlehem is now in a Palestinian territory. I had to change vehicles, but was able to tour the church there at the stable, and then it was onto the Church of the Shepherds. An interesting thing happened as we stopped at the souvenir shop there. The guide from my previous tour was chatting with my current tour guide when he recognized me and said, "Oh my God, This girl can sing! You must get her to sing! She sang such a beautiful prayer for us that we all cried."

And so it was that when we got into the Church of the Shepherds, in a particularly echoey location, the guide asked me to sing. He had just recited Luke 2, the story of the shepherds, and so I sang to them, "While Shepherds Watched," which is the choral summary.

I returned to the hotel for more pool time before packing for the next day to return home. This had been a journey of spiritual as well as historical meaning.

Switzerland, 2018

THE WORLD HEALTH ORGANIZATION WAS meeting at the United Nations in Geneva, Switzerland. Then-health minister, Ginette Petitpas-Taylor had extended an invitation for me to accompany the Canadian delegation.

I had only been in Switzerland once before, in Zurich, when I had been with the chemical company. My recollection is of twenty dollar coffees that came with whipped cream and chocolates; of very modern, stark hotels; and of a people who could understand zero of my German and all of my French.

I agreed, and it was organized. The team included Theresa Tam, the public health officer, as well as the Canadian Ambassador to Switzerland. It was an honour to meet them, and I was very proud to take my seat in the

ornate halls of the United Nations, seated with the others between Chile and Cambodia, as luck and the alphabet would have it.

It was a hectic schedule and most of it remains a blur. We visited safe-injection facilities and methadone clinics, met with officials to discuss world health priorities, and presented a motion to include mental health on the score card for the World Health Organization. It was accepted and endorsed by many other countries, and I felt a huge pride in our country. I was proud to represent Canada and the team celebrated back at the hotel with wine and a great dinner.

One of the things I will remember most about Switzerland, is that outside of the hotels, there was no air-conditioning. As a menopausal woman in a plus-70° temperature zone, these things are noticeable, from the inclination to tear your clothes off in public, or from the sweat prints under the arms, breasts, etc. I was told it was to help the planet, but I wasn't sure how homicidal meno-pausal women were going to help.

The trip was quick, but not so quick that I did not see the beautiful scenery of Switzerland. From the grounds of the UN I saw Mont Blanc and enjoyed a meet and greet there, and I saw the embassy and its grounds, and Lake Geneva and its majesty.

A place to see again.

CHAPTER 21

Key largo,

2019

KEY LARGO ALWAYS CALLS UP visions of romance…
Humphrey Bogart and Lauren Bacall, picturesque sunsets,
fresh ocean views. I had been to Florida a myriad of times
over the years, but was usually farther north in Orlando
or Daytona Beach, or on the Gulf side in Tampa or Fort
Meyers. My brother had moved to a place called Estero on
that side, in a beautiful gated community. I loved to visit,
like all Canadian snowbirds.

My friend Dianne, from Bermuda, had ended up in Fort
Myers after her career had taken her from Toronto, to San
Francisco, and then Texas. Her parents had a place in a
gated community in Fort Myers, and when Dianne retired
it was convenient to get a place nearby, where she could
keep an eye on her aging parents. I had planned to see her

when I was visiting my brother's place. As I was deliberating on what to do, I thought about one of my bucket list items—to sail in Key Largo.

In this age of Google, you can find any service you want, though I tended to be a bit more selective after the Restoule experience. In no time, I had found a company that would take you sailing—up to four people. There was a choice of full-day or half-day experience. I picked out the half-day, and booked it. Dianne was keen to go and suggested we take her SUV, which she wanted me to drive. I was the more experienced highway driver, having spent thirty years driving roads around the globe.

We started out early, driving down I-75. Dianne is not a morning person, so until the caffeine kicked in there were mostly sounds of agreement as I chatted. It was a weekday, so traffic was light, and we caught up on the ten years since we had last seen one another. The sunshine made for a cheery day. We didn't have to hurry, since we didn't need to be at the boat until one p.m. Other than a brief midmorning pit stop, we continued on our way down the I-75 through the Florida Everglades until we hooked up with Highway 1, and headed for Key Largo.

Traffic picked up as we neared the city. When we were about a fifteen-minute drive from our rendezvous with the boat, there was a restaurant named, "Snappers." We had Googled it, and it looked like just what we needed—a place overlooking the ocean, where we could have a few drinks and lunch on the patio before our sail. I love it when a plan comes together. We were amongst three tables of lunch

guests, so the service was great. There was a gentle breeze blowing, and the sun sparkled off the water.

I ordered a pinot grigio and the fish special. We were totally relaxed and by the time we finished up, it was time to head over to where we were to meet "Captain John" for our sail. I parked the white SUV on the side of the road (no other parking appeared to be in sight, and there were several other cars that had done the same. When in Rome…)

We had packed a cooler with the essentials. More wine, chips, and plastic glasses. I slung the cooler over my shoulder and gathered the rest of my stuff, and we made our way to the appointed dock.

A weathered, wiry guy with a scruffy beard appeared on the deck of the sailboat. He had intense blue eyes, and a friendly smile. "Hi, I'm Captain John, are you Marilyn?"

"Yes, and this is my friend Dianne." We shook hands and he helped us aboard. Another, shorter, tanned, and wiry hand appeared. "Hi, I'm Bill," he said. He and the captain left us to chat and start pouring the drinks while they untied the boat and got underway. The boat was a twenty-seven-foot sailboat, in reasonable shape. Sometimes, things are as advertised. Not always, but it is a pleasure when they are.

The day was awesome: breeze blowing our hair, sun tanning our bodies. (We had stripped down to bathing suits, and the guys had taken off their shirts.) We could have been two couples out for a sail. After about an hour and a half, we dropped anchor so we could snorkel. The water was clear as glass, and the fish were varied and colourful. We explored the area. John stayed with the boat, and Bill

stayed with us. The water was warm, and we were enjoying the exercise.

However, as I was swimming over a coral reef, I looked ahead and saw a rather large, ominous-looking fish—a barracuda. I turned and swam in the opposite direction. When I circled a second reef and turned, I again saw this barracuda headed toward me. I swam away, faster this time, my heart starting to pound a bit. I looked back to see this fish still heading towards me. No way was I going to be shark bait. I headed for the boat and quickly climbed out.

I was breathless by the time I had shed my snorkel gear. John laughed and said, "Had enough?"

I explained about how this barracuda had taken three passes at me, and how I was not too sure why it was so interested in me, but I wasn't waiting to find out.

He pointed to my earrings and said, "Maybe don't wear fishing lures next time." He was right. Without thinking I had put my helix earrings on that day. They were long and dangly and silver and were likely catching the light and sparkling. Note to self —if you don't want to be shark bait, don't wear lures.

Eventually Dianne and Bill returned to the boat. We towelled off and pulled up anchor, heading back with a good breeze to speed our return. We were laughing and chatting and munching the snacks. Dianne had worn a hat and had protected her skin with a shirt once she started to burn. Not me. I was lobster-red by the time we returned to the dock, but happy to have spent this great day. Another checkmark for the bucket list.

Dianne and I took our time on the way back. We were hungry, and stopped at an Outback steakhouse, enjoying a Bloomin' Onion with our meals. Full and happy, we continued the drive, watching the orange sunset, with rays of magnificence capping off a perfect day.

CHAPTER 22

Iqaluit,

2020

WHEN MY LEADERSHIP CAMPAIGN TEAM first told me they were sending me to Nunavut, I thought it was a joke. Seriously, I hardly thought the North would be a hotbed of Conservative activity. However, apparently the political strategists had figured out that in the leadership vote, there were a hundred points assigned to each of the 338 ridings, regardless of how many voters were there. So Iqaluit had fifty-five Conservative Party members, sixteen of whom had voted in the last leadership race. So if I could charm sixteen people, I could get a hundred points.

Really, I probably could have talked my way out of it, but I had always wanted to see the north and the Northern Lights, so I agreed. Senator Dennis Patterson had agreed to introduce us around. We were due to fly out at seven a.m.

on the Friday and return early Sunday afternoon. The night before the flight, we got a text from the senator letting us know they were taking us snowmobiling on Saturday, but not to worry, that they would have all the gear we needed.

If there is one thing I have learned in my travels, it's that one size does not fit all. I can't tell you the number of times I was assured there would be equipment, only to end up looking like Spock in short pants, or wearing boots where my toes were at the midpoint. Fortunately, I had skidoo pants and gloves in my Ottawa apartment, so I packed them up. I had some reservations about going snowmobiling. My daughter had been in an accident with my then-husband, and on a trip before that my husband had been dicking around, and I was thrown off the back of one. However, the senator was being kind enough to show us around, so I felt obliged.

The flight on Canada North was actually great. Good service and two free drinks! When we arrived at the Iqaluit airport, it was like stepping into another culture. Inuit art covered the walls and the majority of the population was Inuit. Dennis met us at the baggage collection, wearing a purple wool hat with a tassel, and a seal-skin jacket. After he greeted us we went out into the -32°C sunshine and found his car. This black SUV had what looked to be bullet holes down the one side. I got in the front, and tried to do up the seat belt.

"Sorry, but the seat belts don't work," said the senator.

It seemed to me that in a place where you would be driving on snow-blown and icy roads that seat belts would be sort of essential. Apparently not. The other interesting

thing was that the power steering was broken, and so it was an iterative process to back out and get turned around.

We drove through the downtown of Iqaluit and past the bluffs. The population was about 8,000 people. Our first stop was at the original Hudson Bay Company building. It had been acquired by a company that specialized in drones, used for mapping the north and tracking narwhal populations. The store was right on Frobisher Bay, on which the ice glistened in the bright sunshine.

Our next stop was the Airbnb my travel director, Regan, had booked. We dropped off our stuff. Two bedrooms, decent living room and kitchen/dining area. Nice bathroom. This was going to be great. We had two events that day. One was at the college where I spoke to two classes along with the coaching.

I learned the history of how Nunavut came to be, and about the deal the Inuit had made with the Canadian government. They had been smart enough to hire a geologist, and so when they picked the eighteen-percent of the land they would hold ownership over, it was all the mineral-rich areas. They also negotiated to have their own government for this territory.

We passed what appeared to be a liquor store. The senator explained that it had opened recently but was still very controversial. We decided to go in to experience it. People were lined up, and there was a menu on a TV screen on the wall. Apparently, you had to present identification to show you lived in Iqaluit to be able to purchase, and each person was limited to one twelve-pack or two bottles of wine each day. The store was only open through the week

for limited hours. We got Dennis to buy us two bottles of pinot grigio.

We met with the local doctor, discovering that most of the area did not have a doctor. We heard about the struggles with tuberculosis and addiction. From there we went to a workshop attached to an old building for our meeting with the Conservatives. It was a disappointment. We met about ten of them over the weekend, but only five showed for the event.

The senator suggested dinner at the Legion. We had no food at our Airbnb, so we were game. Snow was falling as we entered the Legion hall. Only members and their guests could be allowed in, so we had to sign in and pay for the coat check. From there, we got a table. That's when we found out it was cash-only, and our dinners with a drink would be about $100. I heard there was an ATM, and I searched it out, but it kept rejecting my card.

The senator came to find out what was taking so long, and he brought his friend, who was the owner. The owner laughed when he saw me at the ATM. He said, "It's a bit finicky—there's a trick to how you stick the card in. Give it here." So I handed him my card, and he effortlessly shoved it in and got it to work first time.

So we had our steak dinners, which hit the spot. We also met Jim, who was to take us snowmobiling the next day. Regan had expressed some concern about this as well, so you can imagine our relief when we found that it was -38 degrees and blizzarding on Saturday, so we couldn't go. We visited with a number of others, lunching at the Legion, which was eighty dollars (another trip to the ATM, but

this time I knew the trick and was able to extract money). We had coffee at the local café, and met with one of the medical researchers.

Regan wanted to get some arctic char to take back home, so the senator took us to "the store." We walked in to what looked like a bit of a shack. Inside the first tiny room were three freezers. I opened the first one. It had frozen squares of narwhal. The second had frozen pieces of char and scallops. The third, more narwhal. The owner heard that Regan wanted a whole fish, so he motioned us to follow him. We went through a room where a narwhal was being hacked into freezable pieces and then into another long room where there was a huge freezer. The owner reached in and took out a char the size of Jim's table. Regan said, "Is there just a small one?" He reached in and brought out one half the size of the table. Forty dollars later we were on our way. We ended up leaving the fish in the SUV for several days, as it turned out.

When the senator had dropped us back at our Airbnb, we could see that there was nothing to eat there. However, our hosts had left a book with numbers of places that delivered, so we ordered a fifty-dollar pizza, which was quite delicious. We had just stuffed ourselves on the pizza, when the senator called and said that Jim was doing an artic char and he was going to come by and pick us up. I told him we had just finished this pizza, but he insisted.

By this time, the blizzard had picked up and you could hardly see across the road. The senator seemed oblivious, backing up and twisting his steering wheel several times to get us on the road.

Jim's place was warm and welcoming. Wine was chilling on the outdoor balcony. Convenient. There was an older Inuit woman preparing the fish...I still can't recall her name, but she looked me over and gave me a glare that clearly indicated she was not pleased. Jim's son Cam was sprawled on the couch, drunk or high or maybe both. He noticed her glare and laughed and said to me, "Don't worry, she just doesn't like white girls."

We sat at the table, the six of us. This char was pretty much the size of the table. I was sure I could not put another bite of anything in me after the pizza, but one glare from the Inuit lady and I graciously took a plate of char, which of course was amazingly delicious.

All of us, including Dennis, were enjoying the wine. When it was time to go, Cam was given the job of driving us home. We started off in one direction, with his truck that had one working headlight. At one point, the road became so blown over with snow it was impassable. So he turned around, (which would have been seven iterations for the senator's SUV), and said, "Well, we will try the other way, and if not we'll have to walk." Walk? In a -38° blizzard with no rope? I've seen that movie.

Fortunately, it worked out and we got to our Airbnb. The wind was howling and the building was actually shaking from the wind. We went straight to bed. Senator Patterson had arranged for us to go to church with him in the morning, and then to have lunch with some Filipino ladies he knew, before dropping us at the airport. Since the cancellation of the snowmobiling event for blizzard

conditions, I was skeptical about whether our flight would actually happen.

Sometimes, I hate being right. Our flight was cancelled. So here we were, in Iqaluit, having only booked into the Airbnb until that morning. We called our host. Fortunately, she worked for the airline, and told us that the next people who were coming in for the Airbnb couldn't get there, so we could stay another night. The senator picked us up, and there were a hale and hearty dozen people there for mass. We arrived afterwards at the home of Apples, Gigi, and Militia. I'm not sure what kind of outcome you are expecting as a parent when you name your daughter Militia, but she was a sweet, intelligent girl who had just returned from New Zealand. Apples was a nickname. Apparently her family members all had fruit nicknames.

You should have seen the spread they put on for us— Filipino noodles with chicken; meatloaf coated with bacon; rice; spring rolls; sausage rolls; a layered Jello (green, red, and yellow interspersed with cream layers—yum!), bowls of fresh fruit; and on and on. You hear about food insecurity in the North, and I had begun to understand from visiting the stores that there is a lot of food available, but it is about three times the price of the same products in the Canadian south. At any rate, we talked and ate and laughed with this lovely family, and it was a good thing our flight was cancelled, because we never would have made it. We got home by about two p.m. with a bunch of leftovers.

Regan and I worked on the campaign and did one of the two puzzles that were in our place. We watched Pitch

Perfect 3, and hit the sack, hopeful that our bookings for the morning flight would happen.

Next morning, the look on Regan's face when she came out of her room said it all..."We aren't getting out until Tuesday night," she said.

We confirmed that we could stay at our Airbnb, but what to do about the fact that we had no food and no wine? We called up the senator, and he said he didn't think any stores were open with the blizzard and that the liquor store wasn't open on Mondays, but he would take us over to check if the grocery store was open. As it turned out, it was. I got a can of spaghetti sauce and pasta. Regan went for the vegan Kraft dinner. Those items, plus a box of cereal and milk, and we were done for fifty dollars. When the senator dropped us off he indicated he had a couple meetings but would try to rustle up a bottle of wine for us.

Regan and I sat at the table. You couldn't see across the street for the blizzard. I did the second puzzle while she worked on her computer. After dinner we decided to watch **Gran Torino** with Clint Eastwood. I had seen it before, but Regan hadn't. We were just getting to the ending when the senator knocked at the door. He had walked the two blocks from his house wearing a backpack full of wine bottles. We invited him in. Regan was engaged in the movie, at the part where Clint gets shot. So she was crying while I was pouring this hooch that Jim had provided, and the senator was babbling away about something.

Once the movie was over, we shut it off. Regan was recovering, saying, "That was soooo good." I asked the senator about the Inuit woman that had been at Jim's place.

I said, "Is that his wife, or…?" Denis was a bit uncomfortable. He said, "No, Jim's wife lives in Ontario. That's his boss. Nobody really asks…"

I said, "I didn't think she liked me much, and Cam had said she didn't like white women, but I thought she was very hospitable."

Dennis smiled and said, "Well, you didn't get off totally unscathed. When Jim was getting the wine for me to bring over she said, 'The white bitch should've brought her own.'"

Dennis finished up his wine and stood up to leave. (I use the term "wine" loosely here.) After he had left, Regan put down her glass, which she had not touched and said, "God, I can't drink that—it's awful!" It was the colour of dark urine and had a bit of a medicinal edge. But hey, any port in a storm. Literally.

Dennis had managed to get on the morning flight. We told him to pick us up and take us there when he went, even though we were on the evening flight. We had to leave the Airbnb, and we had no other means to get there.

As luck would have it, we were on standby for the early flight, and we both managed to get seats. The sun was shining brightly, and it was a clear day. You would never have known the savagery of the weather the day before. As we flew out across this raw and frozen land, I was glad I had come.

Miramichi,

2020

MY DAD WAS FROM NEW Brunswick—Peticodiac. When I was a child, I had spent nearly every second summer visiting relatives there until I was into my teens. To be back touring the province as part of a party leadership race was an odd feeling. The journey began in Moncton, where Regan and I had secured an Airbnb to stay in while we attended events.

We packed our stuff into the rental, a black SUV. Our last event finished at seven p.m., and after that we began the drive to Miramichi. Normally, I was the driver, but I had poor night vision, and Regan, who was twenty-three, had agreed she would drive. Regan didn't have a huge amount of driving experience, but the trip was only supposed to take an hour and a half.

It began to snow as we were leaving—huge, fluffy flakes. It had been raining earlier in the day, and as the temperature dropped, the roads iced over and the snow began to cover the ice. I asked if Regan wanted me to drive, but she said she was fine. It was a good thing there was no one else on the road. She was driving about fifty km per hour on a 100 km highway. My stomach was tense. My jaw was clenched.

I have a fear of driving in snow, made worse by the memory of thirteen accidents I have had, eight of them in snow or freezing rain. I normally don't drive in freezing rain anymore, and I am careful to only drive in daylight if there is snow. Yet here we were, sliding down Highway 11. Regan asked me to make phone calls for the election. I figured my being tense was making her tense.

I made calls, and that passed an hour of time. The snow fell even more heavily as we drove on into the night. Other than an occasional car on the opposite side of the road, there was just us. At our current speed, it would take three hours to get to Miramichi. A couple of times, we started to skid and my heart was in my mouth.

Figuring maybe some soothing music would help, I turned on the radio and found a soft rock station. As the familiar tunes played, I relaxed a bit. Even Regan said the music made it better. We continued on in the dark.

It was ten p.m. when we finally pulled into our hotel. We were exhausted from our nerves being on edge for three hours, and we had not eaten. Fortunately, we had brought the leftovers from the event, and I had purchased a box of wine earlier in the trip. It took a while to settle and sleep,

but we needed to be up for our event, which was a coffee get-together at ten a.m. the next day.

The next morning was bright and sunny. We packed everything into the car and started on our way to the event. We had selected a hotel venue along the river, where two of the local political associations had agreed to meet. The snow was thick on the ground, and the drifts were so high you could sometimes not see around them at intersections.

We continued along the route until we came to the destination. It was a huge, lodge-like location. We could smell the freshly-brewed coffee upon entry. The proprietor led us along the hall to a room, set up with theatre-style chairs and a microphone. We had arrived a half-hour early, and now just had to wait for the rest to arrive. But twenty minutes later, no had one showed. And for twenty minutes after that. There is nothing like a zero showing when both Electoral District Association presidents had agreed to come and bring their folks to make you feel welcome. Even worse, risking our lives on the roads was now for nought.

We paid for the coffee, apologized to the staff, and in total embarrassment, climbed back in our SUV headed for PEI. Miramichi was a mistake.

CHAPTER 24

Prince Edward Island,

2020

AS A CHILD, I HAD travelled many times to Prince Edward Island. I took the ferry every time. I can remember as a small girl, holding my mom's hand and having her and the other three kids get off the ferry to look for my Uncle Windsor to pick us up. My Aunt Kitty was my favorite aunt. She took me under her wing and let me stay over at their place on Brackely Point many times.

They also had a great cottage, where I could run freely on the red clay beach, and wade into the Atlantic, shrieking with glee. We stayed mostly with my grandmother on my mother's side. She lived on Kent Street, with a huge house that had many bedrooms. My brother and sister and I would each claim a room, and then the months would fly by, fishing for mackerel or lobster with my cousin Leon or

digging clams with the family. I was, of course, the black sheep of the PEI crowd because I wouldn't eat any of the mackerel or lobster or clams. The only thing that redeemed me was that I liked the potatoes.

In 1989, the summer before I got married, Mom and I went to visit her relatives and friends on the Island. This time we flew, but we were picked up, of course, by Windsor. It was there that we shopped for a wedding dress, and there that I got the sex chat. (It appeared that I knew more than my mom in this area, so just as well.)

So when I found that we were to do a campaign stop in my mom's hometown of Charlottetown, I was excited. Regan had made the arrangements, and after the Miramichi fiasco, I was glad to be driving up the highway on a bright sunny day, with Regan riding shotgun.

When we reached the Confederation Bridge, I had an epiphany. I had watched the building of the bridge on video, and as an engineer, was fascinated. But I had never driven on it. In the past I had been fearful of even going over bridges like the Welland Canal. But now, as a well-seasoned traveller, I was ready.

The sun was reflecting off the water, and the sky was clear in all directions as we ascended the bridge. I was exhilarated by the view, by the thought of it, and by the excitement that had spread to Regan as well.

She gave directions from there to Charlottetown and eventually to the hotel she had chosen. As I turned on to Kent Street, a familiarity came over me. As it turned out, this was the very street my grandmother had lived on, and the hotel was mere blocks away from where I had spent the

summers of my childhood. Looking out the window, I saw sidewalks I had traversed when young.

It boded well for the evening. I was well received with the Conservative branch, who introduced me as a relative of the Brehaut and Robinson clans, who were well known on the Island.

Later, as we returned the rental car at the airport, I wondered if I would ever be there again. I hope so.

CHAPTER 25

Home at Last

AT THE END OF AN adventure, there is nothing like arriving home: familiar sights; the comfort of getting into your own car, with your favourite radio stations already set; your things just where you left them. That last mile of the drive, where you anticipate being back in your own space—your own bed.

Walking through the door to hear the laughter of your children (or more likely their arguing). The hug from your loved one, feeling safe in their arms. Inevitably there are things to be done: unpacking and laundry, catching up on the local news, and re-connecting with friends.

And finally, as you lie in your bed, the memories from the trip replay in your mind like a movie. You can hear again the sounds of those faraway places. You smell afresh the odours you experienced there. You see in your mind's eye with great detail all that your eyes took in on the

voyage. Through all the times and places I visited, these are the things that stick with me. Smells, sounds, and sights. Friends new and old. Good times and bad.

There may be years yet left to me. I have not re-counted the stories of Cuba, of Egypt, of Hawaii, of Italy, or of the many North American places I have been. I still want to see Arizona; to do a Mediterranean cruise; to see Greece; and tour the Yukon, Northwest Territories, and Alaska. There is much more to see. More to know. More tales to tell. Tales from the Globetrot.